D1415434

IMAGES
of America

MYSTIC

Portersville 1847

I ought to sing our noble river
On whose banks yon colors quiver
It rises up in Lantern Hill
Driving many a cotton mill,
It sweeps right through River-Head
Nor stops at Long Bar's sandy bed,
But passing swiftly Holme's bridge,
Randall's wharf, the fort's high ridge
In whirling eddies round the bend
Near Murphy's point, which is lands end,
By Crow Point's dreary shore
Leaving Fitches Goat Point Store,
By Sixpence Isle, and Penny too,
Of Noank we've the finest view

* * *

So there you have the river Mystic,
In all its glory, grand, majestic
With Mallory's wharves and Cotrill's yard
Nor must we Randalls disregard
Nor Fishes' wharf, nor Mr. Avery's
Nor Iron's ways,
Nor Prentice's slip
Nor Niles place where Baptists dip
Here's Pequot Hill, where they battled
Where bows were bent and bullets rattled.
Here live the names long found in story
The Denisons, in all their glory
The Burrowses of every race,
The Packers too have spread apace
Parkeses, Wolfe, Gallup, Lamb,
Eldredge, Douglass and Brayman;
Fishes, Randalls, Averys, Tifts,
Haleys, Starks, Williams, Clifts
These had their day and have it yet,
But new comers line each street,
Every year these new ones come
(Some had better staid at home),
But never mind, the world is free,
There's room enough for you and me

—Lydia E. Burrows,
a pupil at Portersville Academy

IMAGES
of America

MYSTIC

Mystic River Historical Society

ARCADIA
PUBLISHING

Copyright © 2004 by Mystic River Historical Society
ISBN 978-0-7385-3498-5

Published by Arcadia Publishing
Charleston SC, Chicago IL, Portsmouth NH, San Francisco CA

Printed in the United States of America

Library of Congress Catalog Card Number: 2003114755

For all general information contact Arcadia Publishing at:
Telephone 843-853-2070
Fax 843-853-0044
E-mail sales@arcadiapublishing.com
For customer service and orders:
Toll-Free 1-888-313-2665

Visit us on the Internet at www.arcadiapublishing.com

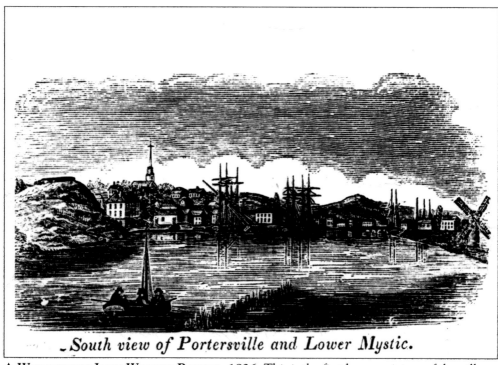

South view of Portersville and Lower Mystic.

A WOODCUT BY JOHN WARNER BARBER, 1836. This is the first known picture of the villages of Portersville (on the left side of the Mystic River) and Mystic Bridge (on the right). The first bridge across the Mystic River sits low on the water upriver. Also depicted are the Mariners Free Church (on the hill to the left) and Beebe's Grist Mill (right) at Pistol Point.

CONTENTS

Acknowledgments 6

Introduction 7

1. Preserving the Story 9

2. Notable Places around Town 19

3. People and Their Places 31

4. Walking through Downtown 47

5. Along and on the River 67

6. Houses and Their History 79

7. After the Sails 91

8. Flames on Main Street 101

9. Other Matters of Interest 111

ACKNOWLEDGMENTS

The Mystic River Historical Society, a nonprofit organization founded in 1973, is pleased to present this volume of historic images in celebration of the 350th anniversary of the settlement of Mystic, Connecticut. Our organization has been fortunate over the years to have been given a wealth of photographs and other materials that tell the story of Mystic. We have relied heavily on these collections in compiling this book, especially on the photographs taken by M. Josephine Dickinson. We are indebted to Horace B. Lamb Jr., who loaned us many photographs taken by his grandfather George E. Tingley. The photographs by Dickinson and Tingley are a vital part of the visual record of Mystic in the first half of the 20th century. Photographs taken by Julia Coates and Elmer Waite, who were also local photographers, were loaned to us by the Indian and Colonial Research Center, located in Old Mystic. The column "Historic Glimpses," written by Groton town historian Carol W. Kimball for the *New London Day,* has been an invaluable resource as well.

We wish to thank the following individuals and organizations who graciously loaned us images: the Akeley Trust; Mr. and Mrs. Robert Cox; Cameron Cutler; the Denison Society; Daniel B. Fuller; Bernie Gordon of the Book and Tackle Shop in Watch Hill, Rhode Island; the Indian and Colonial Research Center; Eleanor Jamieson; Carol W. Kimball; Jim McKenna; the Mystic and Noank Library; the Mystic Art Association; the Mystic Congregational Church; Nancy Strawderman; Barbara Stefanski; Dorothy Szestowicki; and Delight Wolfe.

We would also like to thank the following for their assistance: Lou Allyn, Joanna Case, Joan Cohn, Fritz Hilbert, Carol W. Kimball, Charlie Maxson, Emily Perkins, Mary Katherine Porter, Steve Slosberg, Fritz Stein, Barry Thorp, and Kit Werner. And, of course, our thanks go to our families for their patience and support, as well as for their suggestions and their help.

The narrative is based on original source materials and previously published accounts. The authors take responsibility for any errors in facts found here. For a list of sources and suggestions for further reading, please see page 128.

—Dorothy Hanna and Judith Hicks
for the Mystic River Historical Society

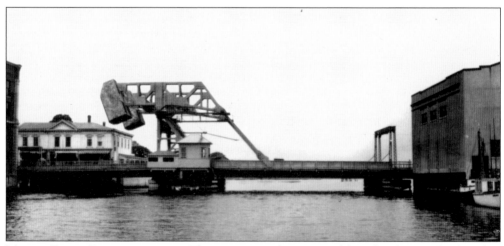

MYSTIC RIVER BRIDGE, C. 1930. This view is easily recognizable today despite the fact that the Strand Theater (right) is no longer standing.

INTRODUCTION

The first recorded name of the Mystic River was Siccanemos (River of the Sachem). De Laet, a Dutch geographer, identified the river on a map he drew of the southern New England coastline in 1616 for Capt. Adriaen Block, a Dutch explorer. The first English settlers in 1654 called the river Mystick, spelled in a variety of ways. The word is a Mohegan word and has been defined as a tidal river whose waters are driven by waves, tides, and winds.

Some of the early settlers were granted large tracts of land by John Winthrop, who in turn had been granted a large amount of land in New England by King Charles II. In 1652, Capt. George Denison was granted 200 acres on the east side of the Mystic River, between what is now known as Masons Island and the river. In 1654, a very large land grant, including an island, was given to Capt. John Mason in recognition of his aid in making this area safe for settlement. Capt. John Gallup also received 200 acres on the river above the Denison grant, and Thomas Miner was granted land between Masons Island and Quiambaug Cove. Major land grants were awarded along the river on the west side as well, extending both north and south. These grants were recorded in such names as Packer, Burrows, Fish, Beebe, Starke, Morgan, and Parks. Descendants of many of these grantees still live in Mystic.

"Mistick" was not built around a common, as many other settlements in Connecticut were. Early settlers here were looking for suitable farming and open pasturelands. They did not settle close to each other, and many times the Mystic River separated them as well. The settlers on each side of the river identified with what would become the towns of Stonington and Groton, east and west of the river, respectively. It would be more than a century before the economic importance of this waterway would be realized and the two sides of the river would come together as a village.

Prior to 1665, the east side of the Mystic River was called Southerton. It was governed by Massachusetts and extended east to the Pawcatuck River. In 1658, the New England Confederacy had ruled that the Mystic River was the proper boundary between Massachusetts and Connecticut. Rhode Island hotly contested this, and it took many years before an agreement was reached to make the Pawcatuck River the boundary line for Connecticut. In 1665, the Connecticut General Court renamed Southerton "Mistick." The west side of the river, however, was also known as Mistick, so in 1666, the court ruled that the east side be renamed Stonington. Within 40 years, residents of the west side (the original Mistick) joined the settlers who owned land east of the Thames River (which in some cases extended all the way to the Mystic River) and asked the court that they be separated from the Pequot Plantations (now known as New London) so they could incorporate as a separate town. In 1705, the General Assembly granted this request and ordered that the area east of the Thames River to the Mystic River be named Groton. The confusion of names and affiliation with towns here in this southeastern corner of Connecticut continues today. Mystic is not a town but rather, as some define it, a state of mind.

In 1815, fewer than 20 dwellings existed on both sides of the river. As more people came to settle, however, small villages (not in a political sense but in a community sense) grew on each bank of the upper and lower river. At the head of the river, the name of the village was Mystic, with some of its land in Stonington and some in Groton. Downriver, small villages evolved on each bank after a bridge was built in 1819. On the west side of the river, Portersville appears as the first recorded village name. The origin of this name is still unknown, but by the 1850s, it had been changed to Mystic River. The area on the east side was called Mystic Bridge. Again, the west side was in the town of Groton and the east in Stonington.

The population and economy grew rapidly in the mid-19th century. Shipyards appeared along the Mystic River. Whaling ships, clipper ships, even an ironclad Civil War vessel, the

Galena, were launched from the many yards up and down the river. Mystic was recognized on the Atlantic coast as a major and quality shipbuilding port. All the residents from both sides of the river were involved with the sea. The merchants provided supplies to the people and the vessels. The population produced not only sea captains who were recognized in ports all around the world, but also many of the craftsmen and investors needed to build and construct the ships. It was a maritime society, and the separate villages were prospering and growing. The Mystic River separated them, but the river was their lifeline for success and a single village was coming together.

The Mystic maritime economy dipped after the Civil War. Steam and iron were replacing sail and wood. The Mystic River could not accommodate these larger new vessels, and the newer building materials were not readily available. The shipyards became deserted, and many of the craftsmen moved on. There was no new industry to draw people into the villages, but despite this economic turndown, the villages managed to remain viable. Many of the old families remained and supported the schools, churches, and local businesses. Life went on, but in a modified manner. In 1890, the U.S. Post Office Department (later the U.S. Postal Service) became impatient with all the villages' names and decreed that Mystic, at the head of the river, be called Old Mystic and that the two villages on the lower river be united and called Mystic. This was the birth of our present Mystic.

Around this same time, the Mystic town fathers set out to boost the waning economy. They formed a group called the Mystic Industrial Company and raised $22,000 in 1894 to establish a subsidiary of a German velvet mill in Mystic. Throughout the century, there had been some manufacturing, but many of these companies were neither large nor long lasting. It was the Rossie Velvet Mill that provided some stability to the Mystic area. In 1905, another company appeared that took the townspeople back to the sailing days. Two brothers from Maine arrived and formed the Gilbert Transportation Company. In the middle of downtown, southwest of the bridge, they built a shipyard for the construction and repair of sailing vessels. They convinced many local investors that sail and wind were still viable for the transportation industry. Unfortunately, they were wrong, and the company went bankrupt in 1909. Despite their ultimate failure, they left a permanent mark on the downtown—the large four-story brick building they built in their glory days. Despite the financial problems of its earlier owners, and the many fires, the Gilbert Block still stands as a prominent structure on West Main Street.

Mystic lost its mill by the middle of the 20th century, and several major fires destroyed various structures, thus changing the appearance of downtown. Mystic became a place to call home, but not a workplace for many. The Mystic Seaport Museum, incorporated in 1929, was expanding and growing in popularity with tourists. Downtown still had stores and shops that offered the everyday merchandise and services that local people needed, including groceries and hardware.

This, too, has changed as we enter the 21st century. Tourism and service industries support the village now, and many of the shops downtown cater to visitors. The grocery stores are gone from Main Street, and the river is used no more for building and launching vessels, but rather for providing recreational opportunities. Pleasure schooners, yachts, and small sailing craft dot the docks and waterway now. A large and beautiful public park occupies the land along the river where the oldest Connecticut lumber company once did business. The original Hoxie House has been restored as a popular inn. Directly across the river, in the former Gilbert Transportation Company shipyard, there are condominiums and another inn with a large yacht tied up at the dock to serve as an annex.

The towns of Stonington and Groton are still the political entities, and the Mystic River, with its unique bascule bridge, still joins the two halves of Mystic and holds this interesting and beautiful shoreline village together.

One

PRESERVING THE STORY

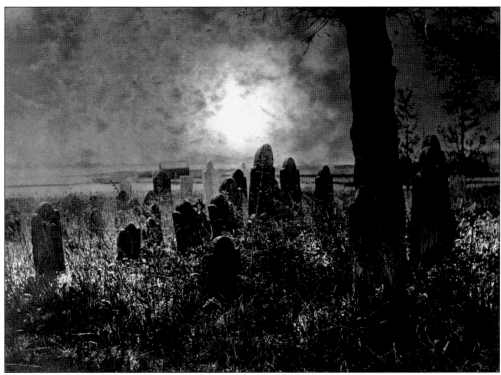

THE DENISON CEMETERY, C. 1899. George E. Tingley titled this photograph *The Light Beyond*. The image attracted world attention and was chosen for the cover of the British publication *Photograms* in 1899. It was described as a unique photograph and "a picture that will live." The cemetery is located on Route 1 at the intersection of Denison Avenue. (Courtesy H. B. Lamb.)

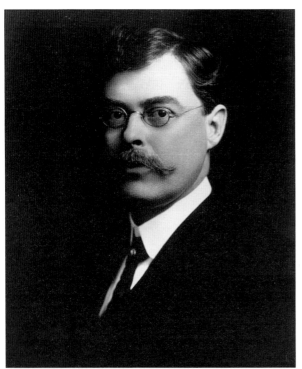

**GEORGE E. TINGLEY (1864–1958),
c. 1900.** George E. Tingley
apprenticed with a Mystic
photographer and later became
internationally recognized for his
landscapes and portraits. Never
going far from downtown Mystic,
Tingley recorded life and scenes of
his time. He paid attention to detail
and composition in order to produce
a truthful picture. The reality in his
photography is a major contribution
to the preservation of Mystic history.
(Courtesy H. B. Lamb.)

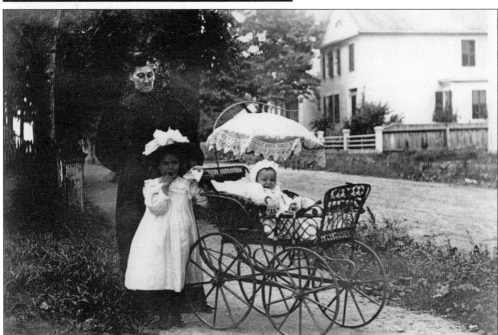

MARY TINGLEY WITH DAUGHTERS RUTH AND MIRIAM, C. 1903. George E. Tingley posed
his wife and children as a family group on Willow Street near their home. The arrangement,
beautiful pram, and Ruth's fancy dress and hat demonstrate the photographer's attention to
detail and composition. He was called upon to photograph many family groups in Mystic.
(Courtesy H. B. Lamb.)

RUTH TINGLEY AND THE CLAM MAN, C. 1903. George E. Tingley posed his daughter Ruth with an unidentified clam man for this striking portrait. A family story says that Ruth was going to be paid 5¢ by her father for participating, but she raised it to 10¢ because, she claimed, the clam man smelled. (Courtesy H. B. Lamb.)

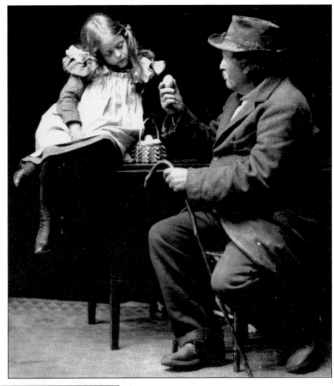

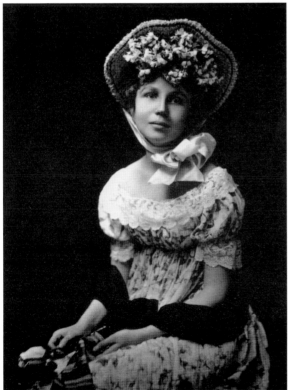

HARRIET CHENEY, C. 1910. Here is a fine example of Tingley's skill in portrait photography. His attention to the lighting and pose resulted in this lovely portrait of Harriet Cheney, a young grammar school teacher in Mystic Bridge. She left Mystic when she married Laurence Griswold of Batavia, New York. (Courtesy H. B. Lamb.)

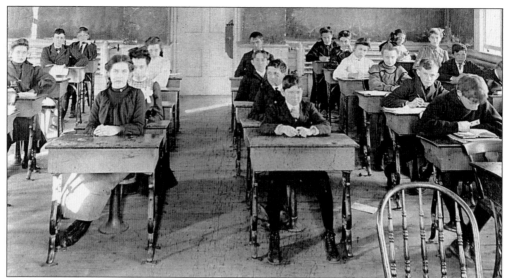

A MYSTIC ACADEMY CLASSROOM, C. 1903. In this photograph, George E. Tingley records his daughter's class at the Mystic Academy. Ruth is sitting at the end of the second row from the right. Note the formal dress code of the time and the photographer's composition of the picture. He posed some of the students looking down at their schoolwork while others are taking note of what is happening. (Courtesy H. B. Lamb.)

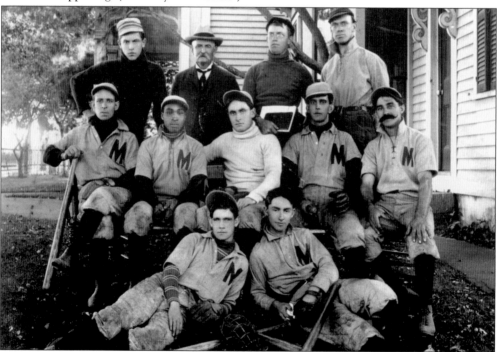

THE MYSTIC BASEBALL TEAM, C. 1902. George Washington Tingley was the Mystic baseball team's coach at this time. He was also the father of the photographer, George E. Tingley. This photograph was taken on Greenmanville Avenue beside the Greenman home, which is now part of the Mystic Seaport Museum. Stephen Mallory stands to the left of George Washington Tingley. (Courtesy H. B. Lamb.)

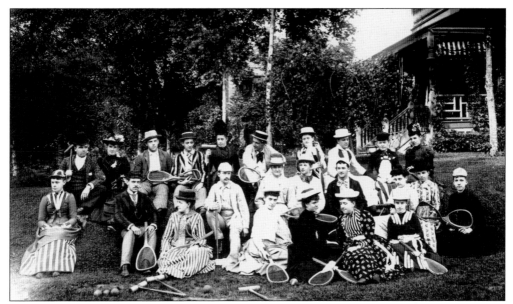

THE MYSTIC TENNIS AND CROQUET CLUB, C. 1905. Mystic young people joined the rage of the day for outdoor recreation. This portrait of the players was probably taken near the recently formed Mystic Country Club on Jackson Avenue. The young ladies and gentlemen may have played a more genteel game in their more formal wear than they would play in today's sports clothes.

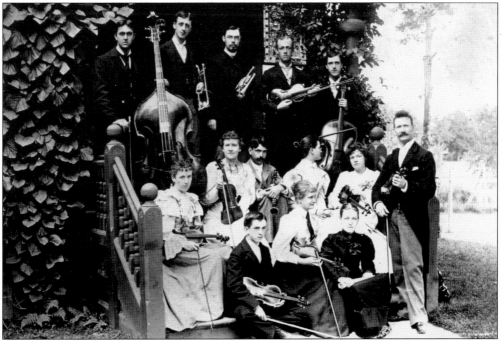

THE MYSTIC ORCHESTRA, C. 1910. Members of the Mystic Orchestra pose on the steps of the Grinnell home, on the corner of East Main Street and Broadway. George Grinnell is in the front row, holding his violin. He later became a music teacher in Mystic. George E. Tingley stands in the back row, holding his cornet.

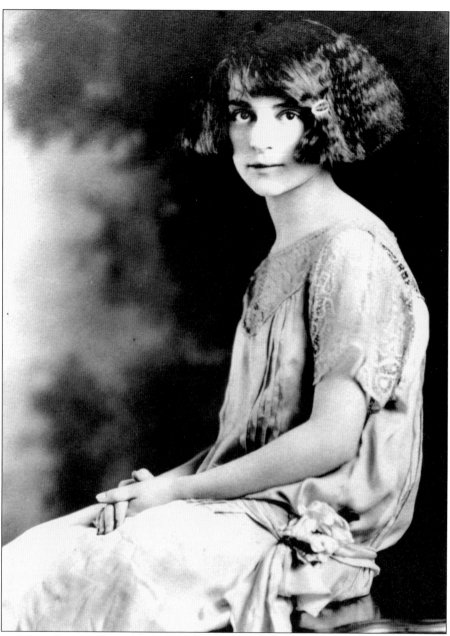

HELEN MAY CLARKE (1905–1989), C. 1925. Helen May Clarke was an exceptionally observant person, and she wanted to be a writer. This combination led her to start a diary at the age of 10. She continued it until she left Mystic at the age of 21, in 1926, and eloped with the love of her life, Dorrance Grimes. She kept various diaries and journals for the rest of her life. After her death in 1989, her husband gave her writings to the Mystic River Historical Society. The society published her first diary as a book entitled *An Account of My Life*. Helen was a descendant of the Burrows family, one of the earliest families to settle in Mystic. She listened to her relatives when they talked about the past, and she recorded the stories, along with her own, in her diary. She has left a written snapshot of a small New England coastal town in the early part of the 20th century.

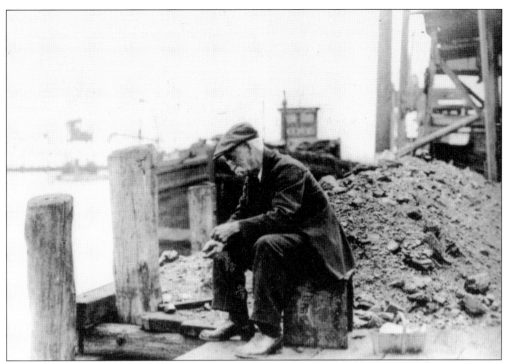

LYMAN HILL (1837–1918), C. 1920. Helen May Clarke's grandfather, who was almost more of a father to her than her own, fishes from a dock on Water Street. She called him "Daddy." Helen was allowed down in the dock area on Water Street only if she were with him or her father because her grandmother said that it was not a proper place for young girls.

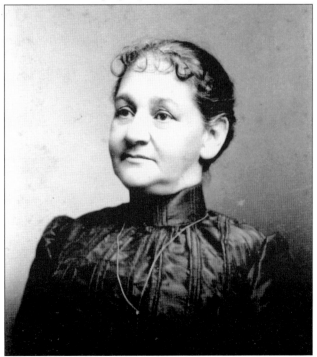

CAMILLA H. BURROWS HILL (1848–1928), C. 1898. Helen May Clarke's grandmother Camilla H. Burrows Hill was a direct descendant of Robert Burrows, one of Mystic's first landowners. His grant, dated April 3, 1651, included mention of "a parcel of land between the west side of the river and a high mountain of rocks." It was through Camilla that Helen heard stories about the families and events that occurred in Mystic long before she was born.

15

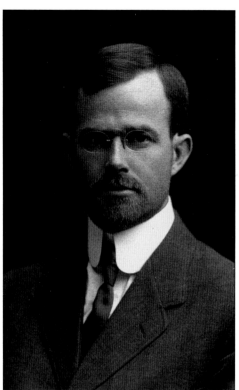

CARL C. CUTLER (1878–1966), C. 1918. Carl C. Cutler, maritime historian and one of the three founders of the Marine Historical Association (now the Mystic Seaport Museum), came to Mystic in 1928. In 1938, he became general manager (and later curator) of the Marine Historical Association. He retired from the museum in 1952 but continued to be active there until his death in 1966. A local middle school is named for Cutler. (Courtesy Cameron Cutler.)

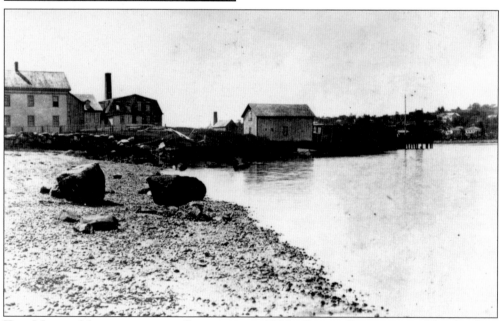

THE MYSTIC MANUFACTURING COMPANY, C. 1920. George Greenman and his brothers built the Greenmanville Manufacturing Company, later known as the Mystic Manufacturing Company, in 1849. It was located on land adjacent to the Greenman Shipyard and the Greenman homes, all on Greenmanville Avenue. In 1931, a granddaughter, Mary Stillman Harkness, gave the buildings and land to the Marine Historical Association.

JESSIE B. STINSON (1889–1982), C. 1920.
Jessie B. Stinson, a Mystic community leader who participated in many civic organizations, was very interested in local history. He collected and took many photographs of the area. These photographs are now a part of the Mystic River Historical Society collection. A summer job at the Groton Savings Bank in 1909 turned into a career of 72 years at the bank. He retired at age 92 as chairman emeritus.

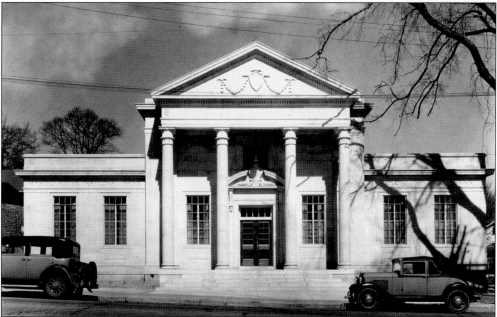

THE MYSTIC RIVER NATIONAL BANK AND THE GROTON SAVINGS BANK, 1933. This bank building looks the same today. In 1851, only the middle section was standing and it was the home of the Mystic River National Bank. In 1931, the two side wings were added to accommodate the Groton Savings Bank. The savings bank built its own building across the street in 1953 and is now the Chelsea Groton Savings Bank.

WARREN B. FISH (1901–1990), C. 1908. Warren B. Fish, shown here at age seven, was the eighth generation of the Mystic Fish family. After retirement, he returned to Mystic and worked to preserve Mystic and Connecticut history. As a trustee of the Elm Grove Cemetery, he remarked, with his keen sense of humor, at a Stonington zoning board meeting that he represented "9,000 people who can't speak for themselves." (Courtesy the Indian and Colonial Research Center.)

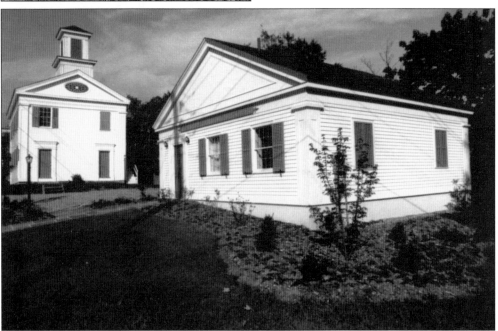

PORTERSVILLE ACADEMY AND THE WILLIAM A. DOWNES ARCHIVES BUILDING, C. 1995. Inside Portersville Academy, a framed commemoration from Gov. Thomas J. Meskill honors Warren Fish for his efforts to preserve the history of Connecticut. Beside that, a bronze plaque from the Mystic River Historical Society dedicates the academy's flags in his honor in recognition of his interest in local history.

Two

NOTABLE PLACES AROUND TOWN

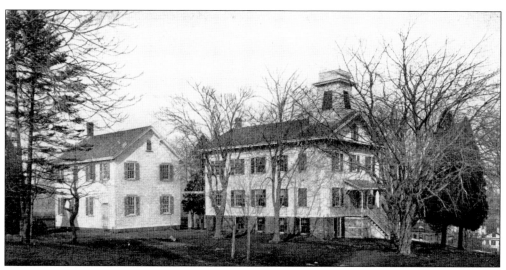

THE MYSTIC ACADEMY, C. 1879. The Mystic Academy, built in 1852, was a private school for both local and out-of-town students. After the school closed in the late 1850s, the building was taken over by the town of Groton and used as the Fifth District School. The town later built a second building for the older students. In 1910, these buildings were replaced by a modern brick structure, which was remodeled in 2000 as a senior citizen residence.

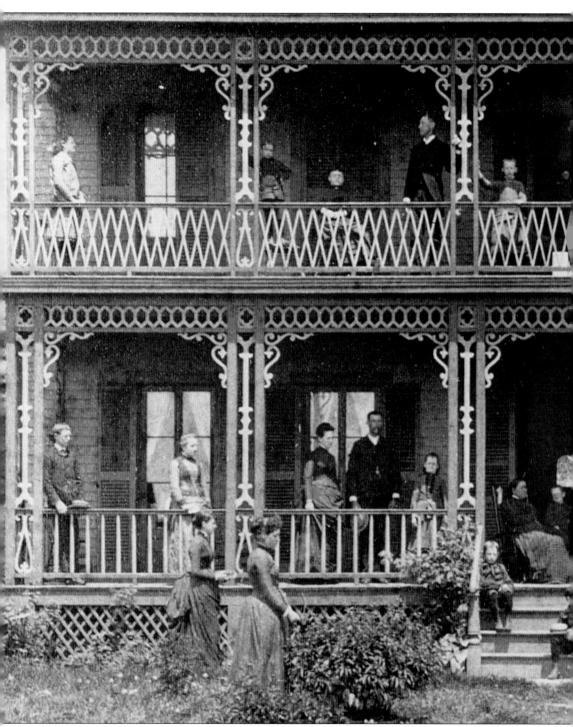

THE BURROWS MANSION, C. 1892. This elaborate home was the second site for Jonathan Whipple's School for Deaf Mutes. He had started his school in 1869 in his home in Ledyard but moved it here in the early 1870s, when the school grew too large. Silas E. Burrows had built this mansion, high on a hill overlooking the Mystic River, just before his death in 1870. Burrows,

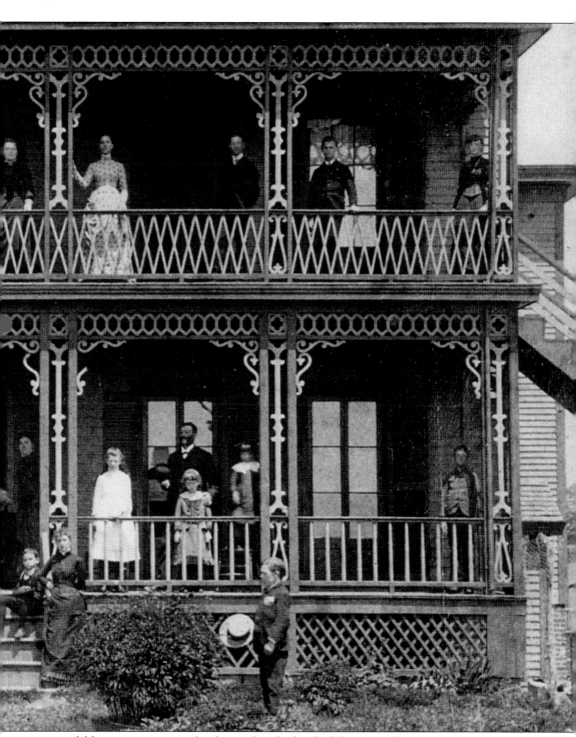

a successful businessman, owned a shipyard at the head of the river, where several vessels were built for his own shipping business. A friend to leaders both here and abroad, Burrows was with Pres. James Monroe when the president died in 1831. (Courtesy the Indian and Colonial Research Center.)

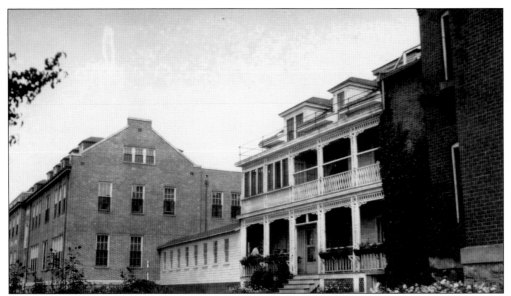

THE MYSTIC ORAL SCHOOL, C. 1925. In 1895, Whipple's school became the Mystic Oral School. After the turn of the century, it had outgrown the mansion, and brick additions were constructed. In 1940, the old wooden building was demolished, and another brick structure was built to connect these wings. The state of Connecticut bought the property in 1921 and continued the school for many years, but it is now used for other purposes.

THE BROADWAY SCHOOL, C. 1909. The town of Stonington built this large brick school in 1908. Children from the east side of the Mystic River attended classes here. The impressive building may have influenced the town of Groton. They built the new Mystic Academy on the west side in the following year. The Broadway School building has been converted to condominiums.

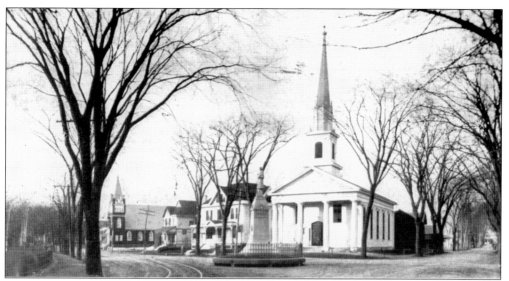

THE MYSTIC CONGREGATIONAL CHURCH, C. 1900. In 1852, when this church was built, the editor of the local newspaper, the *Pioneer,* claimed that this part of Mystic Bridge, on the corner of Broadway and East Main Street, was "out on the plain." By the time the Civil War monument was dedicated in 1883, much more construction had been done in the neighborhood, and it was now a part of the downtown.

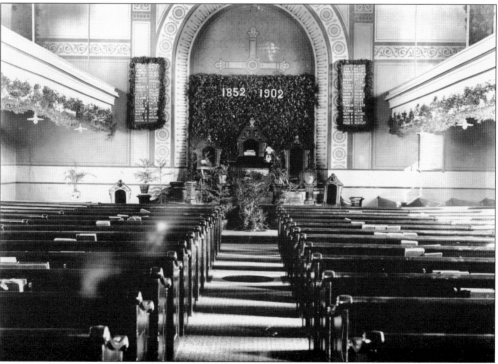

THE MYSTIC CONGREGATIONAL CHURCH, C. 1902. The interior of the church is decorated for the celebration of its 50th anniversary. The plaques on either side of the pulpit record the names of the original 42 members of the Mystic Bridge Congregational Society, formed in 1852. (Courtesy the Mystic Congregational Church.)

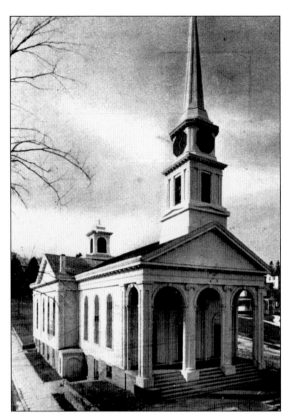

THE UNION BAPTIST CHURCH, c. 1870. The Second and Third Baptist Churches merged in 1861 to become the Union Baptist Church. The Third Church, already here on Zion Hill, was moved back on its lot and turned 90 degrees. Oxen pulled the Second Church building a block north up High Street, and it was placed in front of the Third Church structure, looking east down over the village. The church carillon plays a medley of hymns at noon and at six in the evening.

ST. MARK'S EPISCOPAL CHURCH, c. 1925. A parish that had been meeting as a mission, with occasional services held in Washington Hall, was organized as St. Mark's in 1865. Land was purchased on Pearl Street, and a building committee was appointed. The cornerstone was laid in 1866, and the first service was held on Christmas morning in 1867.

ST. PATRICK'S CATHOLIC CHURCH, c. 1930. The Catholic diocese purchased a church building from the Mystic Methodist Episcopal Society in 1870 and established a Mystic parish in 1871. Rev. P. P. Lalor was the assigned priest. The church was rebuilt and now serves as the parish's community hall. The present sanctuary, next to the hall on East Main Street, was built in 1908 and has been remodeled over the years. (Courtesy the Indian and Colonial Research Center.)

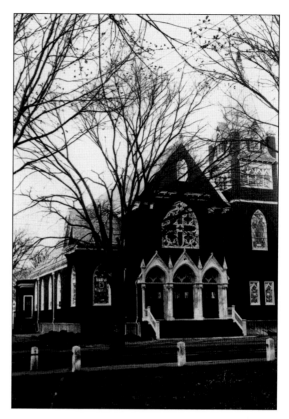

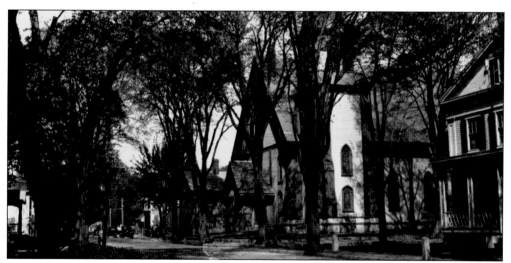

THE METHODIST EPISCOPAL CHURCH, c. 1925. In this view looking up Willow Street (formerly Pistol Point Avenue) from East Main Street, the large Mystic Methodist Episcopal Church is on the right. This was the Methodists' second church and was erected in 1867. It was built debt-free because member Charles Henry Mallory, at the end of construction, assumed all unpaid costs. The church was completely destroyed in the 1938 hurricane.

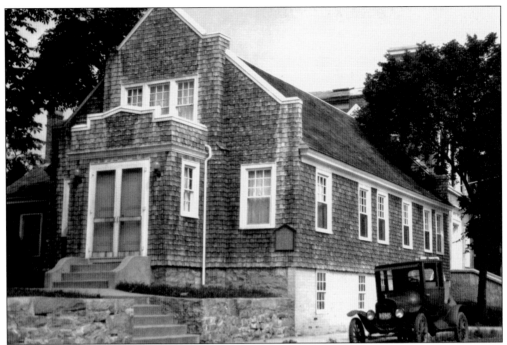

FIRST CHURCH OF CHRIST, SCIENTIST, C. 1920. The Christian Science Society formed in Mystic in 1898. The group had its first reading room in Central Hall on West Main Street. This building, on Gravel Street, was acquired in 1914 from descendants of Capt. William Kemp. Kemp had purchased the property in 1827 from the original owner, Capt. George Wolfe. Little of the original structure remains.

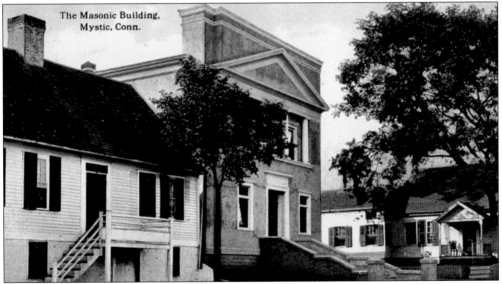

THE MASONIC BUILDING, C. 1920. The Charity and Relief Masonic Corporation built its meeting place here on Gravel Street in 1911. Prominent Mystic businessman Allen Avery, a member of the organization, had purchased the land for the lodge from Mary Forsyth Wolfe. The Mystic Lodge, chartered in 1825, previously held meetings in Central Hall, on West Main Street. (Courtesy Bernard L. Gordon.)

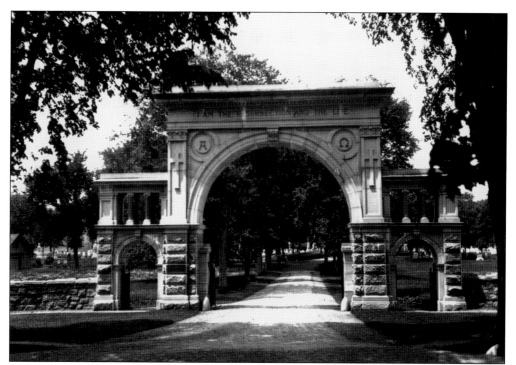

THE MALLORY ARCH, C. 1930. In 1853, the Elm Grove Cemetery Association purchased land on the east side of the river. The cemetery was designed to resemble an elm tree, and two large elm trees flanked the entrance. In 1892, Charles H. Mallory's family commissioned this arch in his memory, and the elms were taken down over the objections of many Mystic residents. The arch was dedicated in 1895. (Courtesy the Indian and Colonial Research Center.)

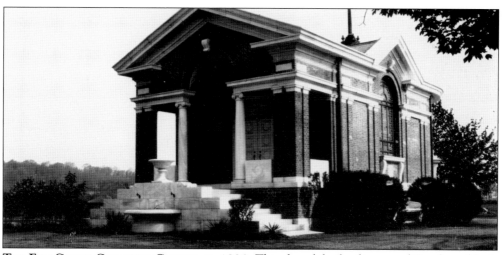

THE ELM GROVE CEMETERY CHAPEL, C. 1930. This chapel, built of imported Greek marble, is located in the northwest section of the cemetery. It was a gift from Mary Stillman Harkness and her husband, Edward S. Harkness, in memory of her parents and grandparents. The cornerstone was laid in 1911.

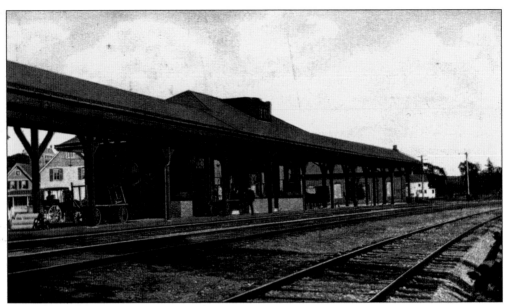

THE MYSTIC RAILROAD STATION, C. 1925. The exterior of the station looks the same today as it did when built in 1907. In 1977, the station and grounds were restored through the efforts of a group of Mystic citizens who organized as Mystic Depot Inc. The station has been used as a model for Lionel electric train sets.

THE MYSTIC TELEPHONE EXCHANGE BUILDING, C. 1925. In 1895, telephone service was installed in 30 Mystic houses at a charge of $18 per subscriber. The telephone became very popular, and in 1899, this building was constructed to consolidate the Pawcatuck, Stonington, Mystic, and Old Mystic exchanges. The building still stands at the corner of Washington Street and Broadway.

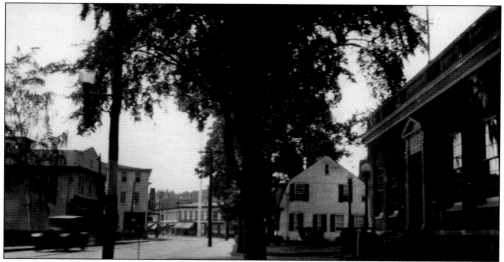

THE MYSTIC POST OFFICE, C. 1925. In 1890, the U.S. Post Office Department combined the villages of Mystic River and Mystic Bridge into Mystic. The Mystic post office occupied several different rooms along Main Street prior to 1925, when the present post office was built and dedicated. It was built in Asa Fish's former garden on the corner of Willow and East Main Streets. His house (left) still stands.

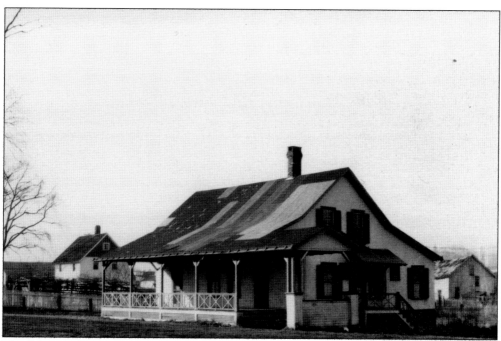

THE MYSTIC COUNTRY CLUB, C. 1925. The Mystic Country Club, organized in 1904, elected Mystic dentist George S. B. Leonard as its first president. The club was located on Jackson Avenue and featured social activities and lawn games. In 1918, during World War I, the club was offered to the American Red Cross for servicepeople to use as a reading room.

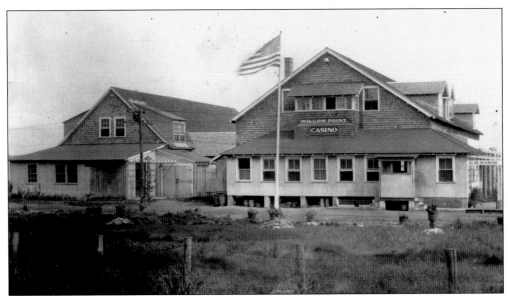

THE WILLOW POINT CASINO, C. 1930. The Willow Point casino opened in 1915. An advertisement in the local newspaper announced fox trot contests Monday through Saturday evenings. The cost was 28¢ for men and 17¢ for women. Patrons came by trolley or ferry. The building burned in 1931 and was not rebuilt, but the road is still called Casino Road. (Courtesy Dorothy Szestowicki.)

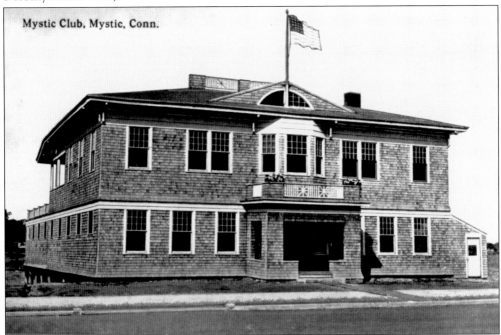

THE MYSTIC CLUB, C. 1915. The Mystic Club (formerly the Mystic Cosmopolitan Club) built this clubhouse on Holmes Street in 1911. It included bowling alleys, billiard rooms, a kitchen, and a library. In 1921, the Community Club took ownership. Gym classes, bowling leagues, and pool clubs formed. As Mystic changed, club membership declined and the building fell into disrepair. It was taken down in the 1950s.

Three

PEOPLE AND
THEIR PLACES

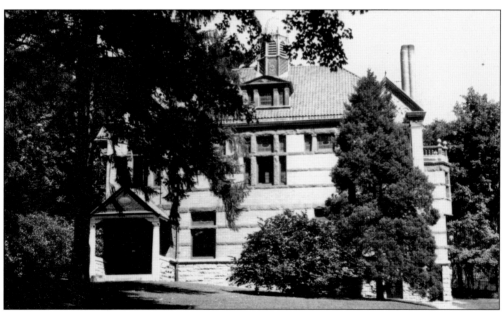

THE MYSTIC AND NOANK LIBRARY, C. 1930. Capt. Elihu Spicer's design for the library called for a meeting room on the first floor, with the library on the second. Throughout the building, the hand-carved oak woodwork displays intricate patterns that hint of a sailing ship. Italian marble, leaded glass windows, and a slate staircase enhance this beautiful building. Both floors are library space now, and in the early 1990s, a large addition was dedicated.

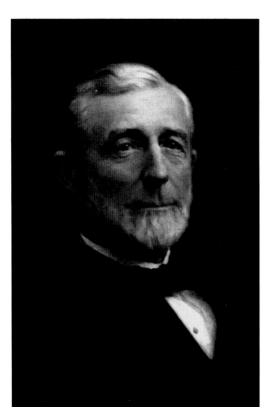

Elihu Spicer (1825–1893), c. 1880. Capt. Elihu Spicer went to sea as a cabin boy and eventually commanded clipper ships. After retiring from the sea, he entered into partnership with C. H. Mallory, transporting cargo from New York to Galveston. In 1893, he constructed a library on Elm Street, opposite his home, for the villages of Mystic, Old Mystic, and Noank. Unfortunately, he died from injuries suffered in a carriage accident just before the dedication of the building in January 1894. (Courtesy the Mystic and Noank Library.)

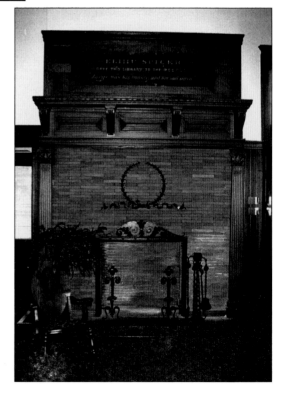

The Mystic and Noank Library Fireplace, 2003. At the far end of the second floor of the library stands this beautiful fireplace made of brick and hand-carved oak with black-iron decoration. The gold-leaf plaque reads, "Elihu Spicer Gave This Library To The People. Large Was His Bounty And His Soul Sincere."

CAPT. HENRY S. STARK (1820–1857), C. 1850.
Born in Mystic, Henry S. Stark went to sea at the age of 15 and became master of several ships in the southern cotton trade. He commanded three Mystic ships on voyages to Mexico, Italy, and Hawaii between 1847 and 1856. In 1857, he died in Mystic at age 37. (Courtesy Mr. and Mrs. Robert Cox.)

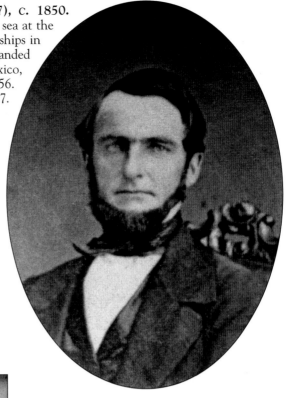

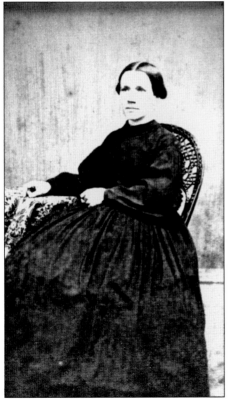

MARY RATHBUN STARK, C. 1850. Born in 1826 in Mystic, Mary Rathbun Stark was a strong woman. She raised four children while Henry S. Stark was at sea, and supervised the building of their home. She accompanied her husband on his last voyage to Honolulu from 1854 to 1856, when he was commander of the *B. F. Hoxie* on the ship's maiden voyage. (Courtesy Mr. and Mrs. Robert Cox.)

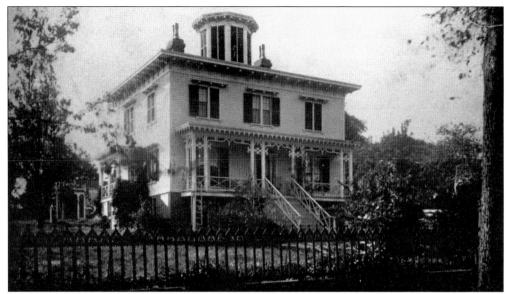

No. 6 West Mystic Avenue. This lovely Italian Villa–style home, with its octagonal cupola, was built for Mary and Henry Stark in 1852. Mary had to supervise the whole process while her husband was commanding the bark *Ocilla* on a voyage to Italy. West Mystic Avenue was then called Skipper Lane because so many captains were building their homes there. (Courtesy Mr. and Mrs. Robert Cox.)

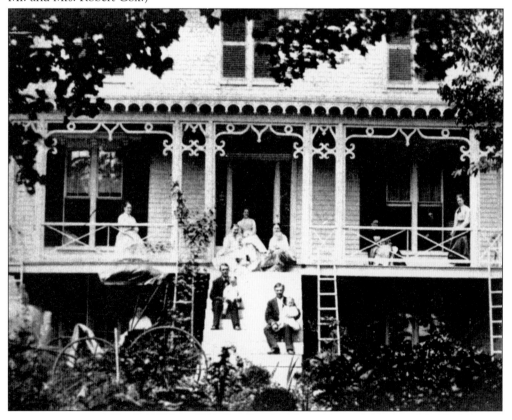

CAPT. GURDON GATES (1814–1892), C. 1854.

Capt. Gurdon Gates, born on a Groton farm, soon discovered farming was not for him. At age 15, he went before the mast and, at age 43, was master of the clipper ship *Twilight*. He commanded many other vessels, including the steamship *Victor* during the Civil War. Retiring from the sea in 1872, he became active in Mystic's political and business affairs. He died in 1892.

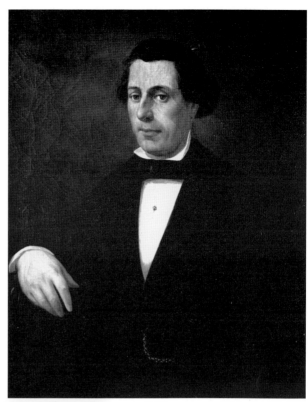

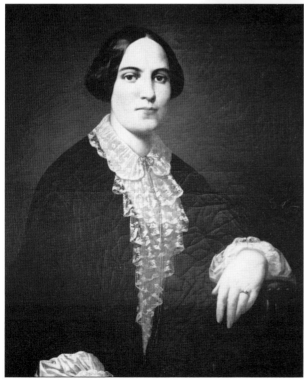

MARTHA PHELPS GATES,

c. 1854. Martha Phelps married Gurdon Gates in 1853. She was his second wife and bore him seven children. These portraits of Martha and Gurdon were painted by Eugene Legendre of Antwerp and may have been wedding portraits. They are on loan to the Mystic and Noank Library from the Mystic River Historical Society and hang on the second floor to the left of the fireplace.

No. 15 Gravel Street, c. 1980. This Greek Revival home was built in 1835 for Daniel Edgecomb, a cabinetmaker who made coffins in his basement workshop. In 1847, Capt. Gurdon Gates bought the property and added some Victorian touches, perhaps to keep up with his fellow captains who were building fancy homes up on Skipper Lane. He and Martha raised their family here along the Mystic River.

No. 19 Gravel Street, c. 2000. Capt. John E. Williams lived here, up the street from Capt. Gurdon Gates. This was the second Williams house, the first having been relocated to Pearl Street in 1860, when John Williams built this home for his new bride. Williams, known as a "hard driver," was commander of the *Andrew Jackson,* which set a speed record for a clipper ship sailing from New York to San Francisco.

CAPT. JEREMIAH HOLMES (1782–1872), C. 1865.
Capt. Jeremiah Holmes, a hero in the Battle of
Stonington in 1814, was owner and captain
of many Mystic sloops involved in southern
trade. As one of the most respected men
in Mystic, he was asked to raise the flag
at the Liberty Pole on July 4, 1865,
a particularly festive occasion after
the end of the Civil War. (Courtesy the
Mystic Congregational Church.)

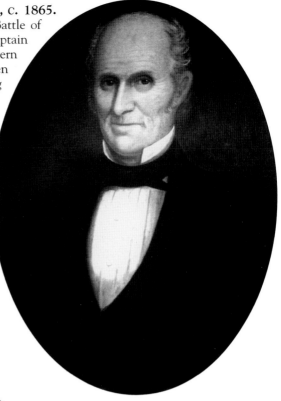

**ANNE BORODELL DENISON GALLUP
HOLMES (1784–1873), C. 1865.**
Anne Denison, a descendant of
Capt. George Denison, married
Jeremiah Holmes in 1809 after the
death of her first husband, John
Gallup. The couple had nine children
and celebrated their 50th wedding
anniversary with the whole village in
1859. Cannons were fired that morning,
and their home was filled with guests until
late in the evening. (Courtesy the Mystic
Congregational Church.)

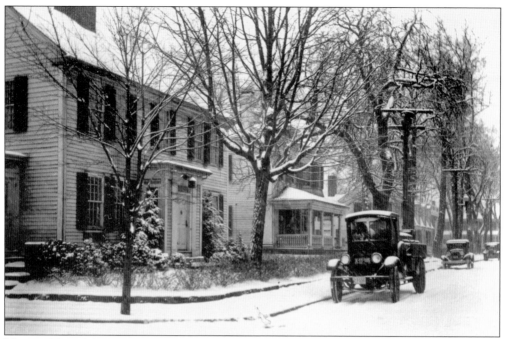

No. 17 East Main Street, c. 1910. Anne and Jeremiah Holmes's dwelling was built on the east side of the Mystic River in 1813, six years before any bridge crossed the river. One of the first homes in this neighborhood, the house stood until 1939, when it was razed. Their property, on the corner of Holmes and East Main Streets, is now commercial and has the address of 2 Holmes Street. (Courtesy H. B. Lamb.)

The Stonington Battle Centennial Parade, 1914. Stonington held a three-day celebration in August 1914 to remember and honor those few men and women who held off the British at Stonington Point during the War of 1812. This postcard shows the float carrying the actual Stonington battle flag, which is held by Jeremiah Holmes's descendant William K. Holmes Jr. Another descendant attended the celebration—a great-great-granddaughter from Providence.

WILLIAM H. POTTER (1816–1892),
c. 1870. William H. Potter, a Yale
graduate, was the first teacher at
Portersville Academy in 1840. He
married Bridget Rathbun, a Mystic girl,
and they had two daughters. In 1851, he
became president of Brandon College in
Mississippi. After his return to Mystic
in 1855, he was very active in local
education, the Union Baptist Church,
and town and state politics. (Courtesy
Judy Hicks.)

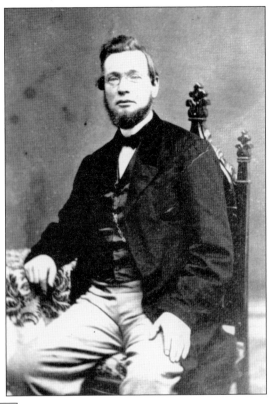

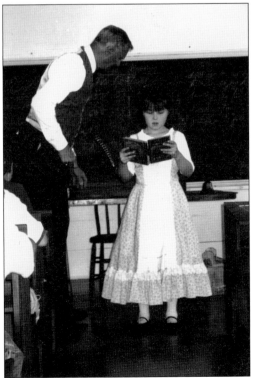

SCHOOLMASTER "MR. POTTER," 2003.
Each spring, the Mystic River Historical
Society invites local schoolchildren to
visit Portersville Academy to experience
school as it would have been in 1849.
The historical society's Mr. Potter, a role
currently played by Russell Leonard, teaches
reading, writing, and arithmetic and sees
that the children conform to the school
etiquette of the past.

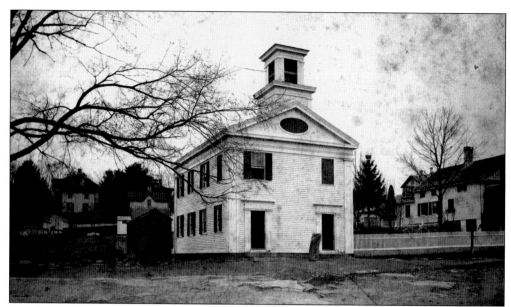

PORTERSVILLE ACADEMY, C. 1870. Shown here in its original location, north of the Union Baptist Church on High Street, Portersville Academy was built in 1839 by the town of Groton as its Fifth District School. The Greek Revival architecture and fine craftsmanship of local builder Amos Clift brought admiration from many leading educators. The two front doors provided separate entrances for boys and for girls. (Courtesy Daniel B. Fuller.)

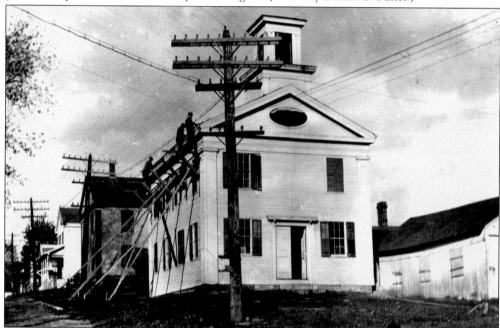

THE MYSTIC DISTRICT HALL AND LOCKUP, 1905. Portersville Academy, which was moved to its present site on lower High Street in 1887, also served as Mystic's town hall. The small building to the right was the local jail. In 1975, the Mystic River Historical Society obtained the property and restored the academy. Now, local schoolchildren can step back in time by participating in an 1840 classroom experience with teachers "Mr. Potter" and "Miss Williams."

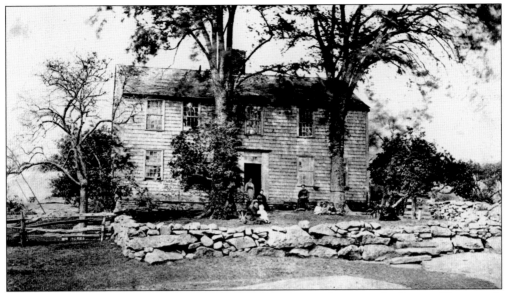

THE DENISON HOMESTEAD, C. 1890. Pequotsepos Manor, now known as the Denison Homestead, was built by Capt. George Denison in 1717 for his bride, Lucy Gallup. The property has been passed down only to Denisons for seven generations. As a museum, each room is decorated to depict the eras of each of those seven generations. (Courtesy the Denison Society.)

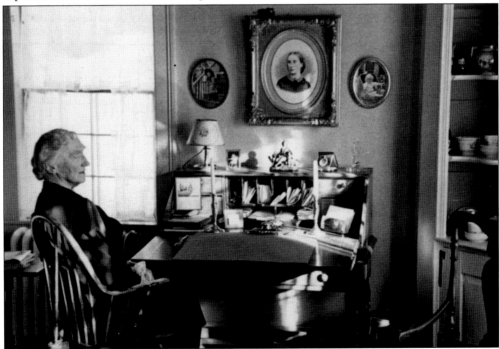

ANN BORODELL DENISON GATES (1866–1941), C. 1935. "Aunt Annie" Denison, pictured here in her front parlor, was brought up in the Denison Homestead by two aunts. She married Nathan Stanton Gates in 1888, and he bought the homestead from the family estate in 1913. When Nathan Gates died in 1920, Ann created the Denison Family Society. After her death in 1941, the homestead became a museum. (Courtesy the Denison Society.)

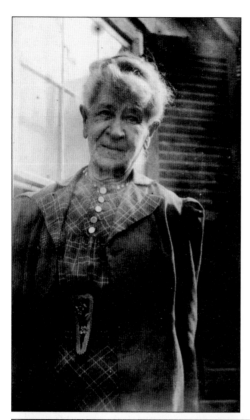

JENNIE ELLA WOLFE (1862–1945), C. 1937. Jennie Ella Wolfe was born and brought up in this house on Gravel Street. Her grandfather Capt. George Wolfe had built it for his bride in 1818. Her father, Giles Wolfe (a maritime carpenter and machinist), inherited the property. At the death of her mother, Jennie Wolfe remained here and ran a seamstress business. (Above, courtesy Delight Wolfe; below, courtesy H. B. Lamb.)

MARY L. JOBE, C. 1920. Mary Jobe, a mountain climber and explorer, opened a camp for young girls in 1916 on the Mystic River where the Universal Peace Union had once held summer conventions. She advertised her camp as "real Western camping, a bit of the West in the East." The camp operated for 15 seasons. After the death of her husband, the African explorer Carl Akeley, Mary closed the camp in 1930. (Courtesy the Akeley Trust.)

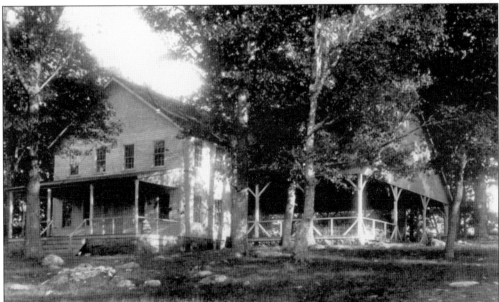

CAMP MYSTIC, C. 1925. Camp Mystic included this building and open pavilion, built in 1896 by the Universal Peace Union. The 100-foot square pavilion served as a dining room and meeting place. Activities were also held in the house, where there were, according to advertisements, "an open fire, lighting and sanitation." Campers lived in tents named after peaks or mountains in the Northwest and wore uniforms of white middies and blue bloomers.

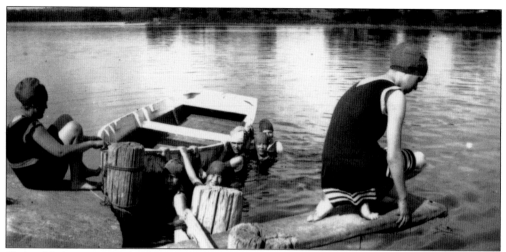

CAMP MYSTIC, C. 1920. Water sports were very popular at Camp Mystic. Swimming and canoeing in the Mystic River, the city girls experienced the fun of being near the seashore in Mystic during the summer. They were also introduced to open-air sleeping, with all its nighttime creatures, on Mystic Island. For some campers, this was no fun. (Courtesy the Akeley Trust.)

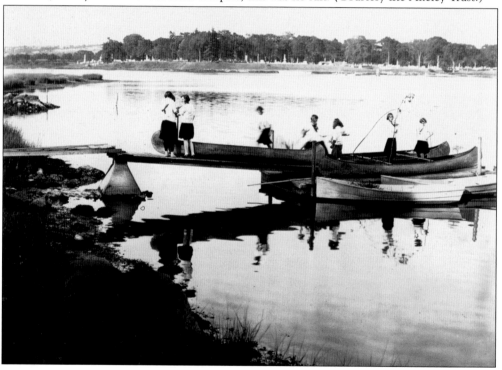

44

CHARLES DAVIS, C. 1900. Charles Davis, recognized both here and abroad for his Impressionist landscapes, settled in Mystic in 1891. When he began teaching here, he attracted a number of fellow artists and students who joined together in 1914 to form the Society of Mystic Artists. Their first exhibition was held that year in the Broadway School. (Courtesy the Mystic Art Association.)

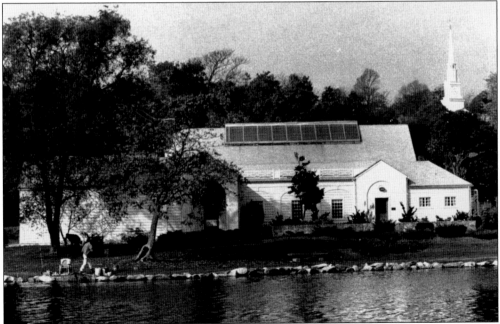

THE MYSTIC ART ASSOCIATION, C. 1970. In 1931, Mystic artists were attracting national attention. The Society of Mystic Artists changed its name to the Mystic Art Association and raised enough money to purchase land along the Mystic River and to build this gallery. It became a popular center for exhibits and lectures and now hosts weddings and civic affairs as well.

The Mystic Art Association

Incorporated

EIGHTH ANNUAL

Exhibition of Paintings

August 11th to 24th, 1921

□□

CATALOGUE

1	Early Autumn	Ernest H. Barnes
2	Island Madonna	Lester D. Boronda
3	Sunlit Woods	Howard Giles, A. N. A.
4	Young Woman	Howard Giles, A. N. A.
5	Maine Woods	Howard Giles, A. N. A.
6	Sleigh Bells	Kenneth Bates
7	Nellie	Murray P. Bewley
8	The Old Red House	G. Albert Thompson
9	The Leviathan	Frederick J. Waugh, N. A.
10	Marcia	Murray P. Bewley
11	Mary, Shepherdess	Frances D. Davis
12	Ingrid	Sherman Potts
13	Queensboro Bridge	Peter Marcus
14	The Lower Road	Frances Orr
15	The Harbor	Julius Joseph
16	An Autumn Day	Walter Griffin, A. N. A.
17	Portrait of Madame T	George Bellows, N. A.
18	Prelude	Lester D. Boronda
19	Ann in Black	George Bellows, N. A.
20	Venice, Bridge of St. Treviso	Walter Griffin, A. N. A.
21	The Silver Screen	Frank W. Benson, N. A.
22	Apple Blossoms	G. Albert Thompson
23	The Window Blind	Joseph DeCamp, N. A.
24	Rural Scene	Daniel Garber, N. A.
25	Wind Driven	Charles H. Davis, N. A.
26	Red and Gold	Joseph DeCamp, N. A.
27	October Afternoon	G. Albert Thompson
28	Proserpine	Frances D. Davis
29	Brooklyn Bridge	Peter Marcus
30	Cliffs of Lantern Hill	Frederick Detwiller
31	The Asa Fish Homestead	G. Victor Grinnell
32	The Glen	Daniel Garber, N. A.
33	Old Houses, Stroudswater	Walter Griffin, A. N. A.
34	Serenity (Moonlight)	Charles H. Davis, N. A.
35	Trees and Cat-tails	Carl Lawless
36	Sunny Afternoon	J. Eliot Enneking

Sculpture

37	Portrait of My Daughter	Harry Lewis Raul

Glass Panels

by Frances D. Davis

1	The Quest
2	The Angel of the Lilies
3	St. Martha
4	Pelleas & Melisande

Prices of Pictures may be obtained at the Desk

A MYSTIC ART ASSOCIATION EXHIBIT, 1921. This exhibit was held in the Broadway School before the Mystic artists had their own gallery. It is notable that many of the artists who are showing their work here were members or associate members of the prestigious National Academy in Pennsylvania. Mystic was becoming an important center for American Impressionist painters, many of whose works are still in great demand.

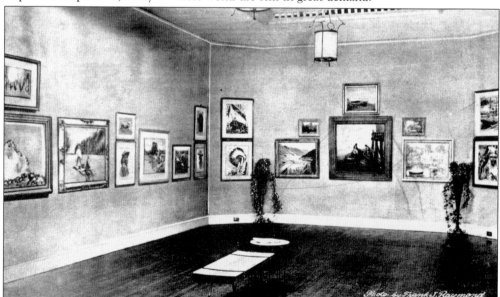

THE MYSTIC ART ASSOCIATION GALLERY, C. 1940. Frank Raymond, a local newspaper photographer, took the picture for this postcard showing the Mystic Art Association's Small Gallery. Among the artists included in this exhibit were Robert Brackman, Kenneth Bates, and Harve Stein. The gallery is now named in honor of the Otto E. Liebig family.

Four

WALKING THROUGH DOWNTOWN

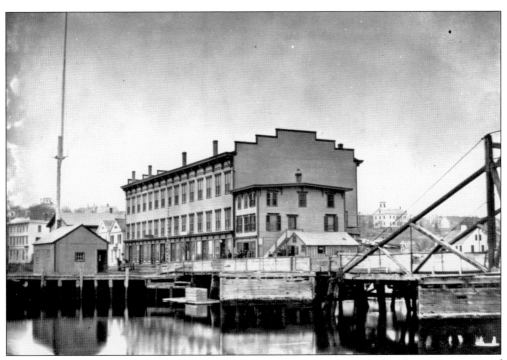

CENTRAL HALL, C. 1865. Central Hall, built in 1863 on West Main Street just west of the bridge, was the largest and most elegant building in town. The first floor housed shops; the second, offices and apartments. The third floor was divided into two halls where roller-skating, lectures, socials, and meetings took place. The building suffered several fires over the years, and in 2000, a final fire destroyed it completely. (Courtesy H. B. Lamb.)

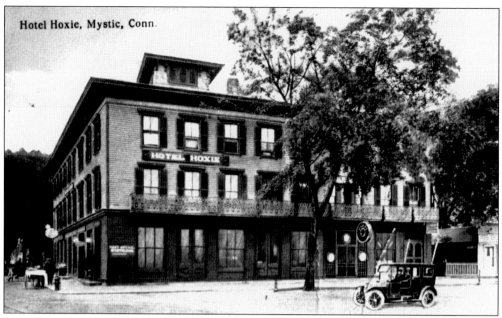

Hotel Hoxie, Mystic, Conn.

THE HOTEL HOXIE, C. 1910. In May 1861, Benjamin Hoxie opened an elaborate hotel for Mystic visitors to experience the beauty and healthful air of a seaside resort. Unfortunately, the Civil War took precedence, and vacations were not that popular. However, the idea of a hotel survived, and today, after physical and fiscal problems over the years, the Hoxie House has been restored and once again offers accommodations for those who visit Mystic.

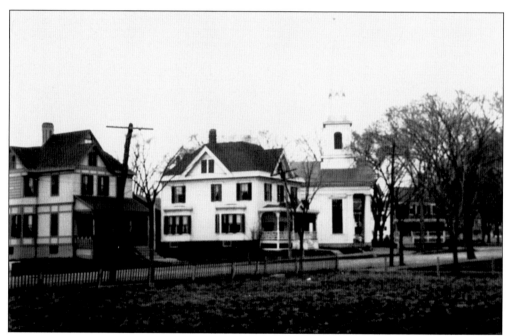

THE COATES HOME AND THE MYSTIC CONGREGATIONAL CHURCH, C. 1881. Dr. Elias F. and Dr. Frank A. Coates lived and practiced medicine here. Their house was built c. 1875, but the church was built earlier, in 1852. (Courtesy the Indian and Colonial Research Center.)

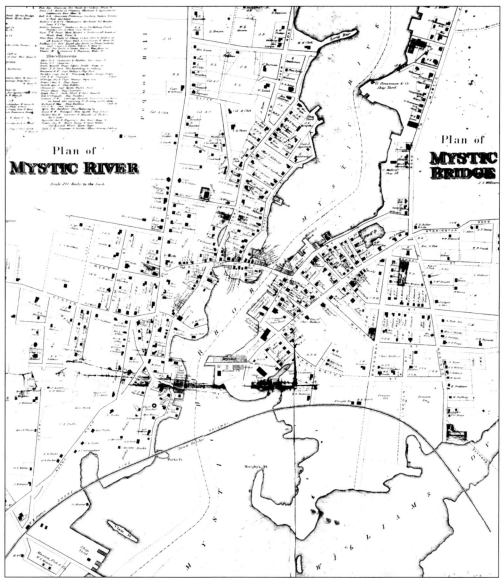

AN 1868 MAP. This map, published by Beers, Ellis and Soule in 1868, indicates that the land to the west of the Mystic River was called Mystic River. The land to the east of the river was Mystic Bridge. In the late 1890s, the U.S. Post Office Department combined the two into a village called Mystic. The village that had been known as Mystic, at the head of the river, was renamed Old Mystic.

49

E. B. NOYES IN HIS BUGGY, c. 1875. E. B. Noyes drives his buggy down West Main Street toward his dry goods store in Central Hall. He opened the business in 1872, and it remained in the family until 1989. Over those years, the store occupied seven different locations in Mystic. (Courtesy Daniel B. Fuller.)

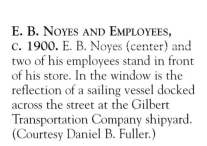

E. B. NOYES AND EMPLOYEES, c. 1900. E. B. Noyes (center) and two of his employees stand in front of his store. In the window is the reflection of a sailing vessel docked across the street at the Gilbert Transportation Company shipyard. (Courtesy Daniel B. Fuller.)

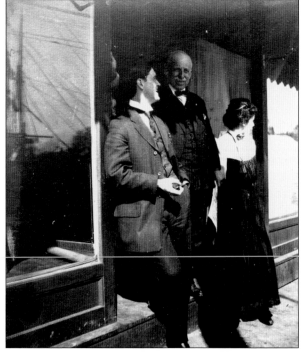

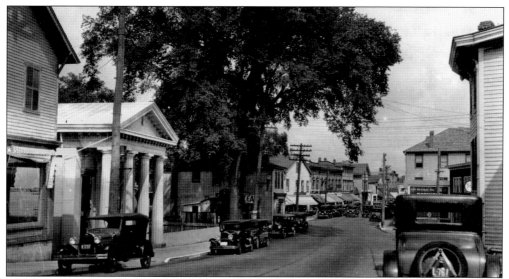

WEST MAIN STREET, C. 1920. It is a busy day in downtown Mystic, and parking spaces are scarce. The building at the extreme left is now Mystic Pizza. The building on the right is now the site of the Chelsea Groton Savings Bank. Just behind the elm tree is a diner doing business in a discarded Groton and Stonington trolley car. The big elm tree was taken down in 1959.

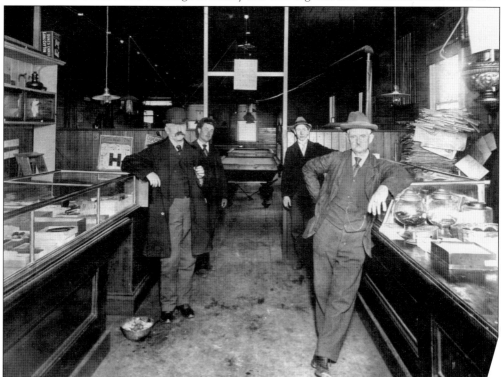

TINGLEY'S BILLIARD ROOM, C. 1900. George W. Tingley (front right) poses in his billiard par¹ located in the Opera House on the corner of East Main and Cottrell Streets. He sold a few ite but his main business was in the back room. The light fixtures seen in the back were low during games. Tingley's son George E. Tingley took this photograph. (Courtesy H. B. Lamb

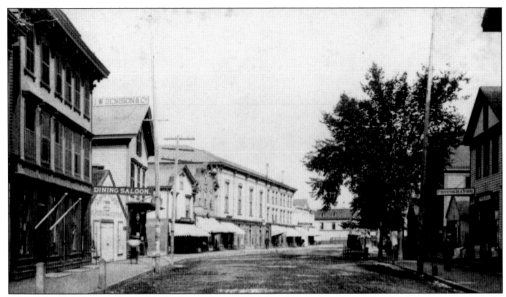

WEST MAIN STREET, C. 1895. This view is little changed today. The buildings on the left, along West Main Street, still stand with the exception of the three-story Central Hall in the background. On the right side of the street, another tree grows in the same location as the one seen here, and the building behind it still stands.

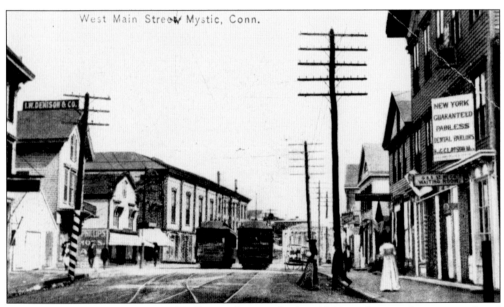

WEST MAIN STREET, C. 1905. Trolley tracks were laid in 1904, and a switchover was placed here on West Main Street near Gravel Street. The buildings to the right have not yet been ravaged by fire, but the tree seen in the earlier view has been removed. In the Avery Block, a dentist advertises an ideal treatment for aching teeth.

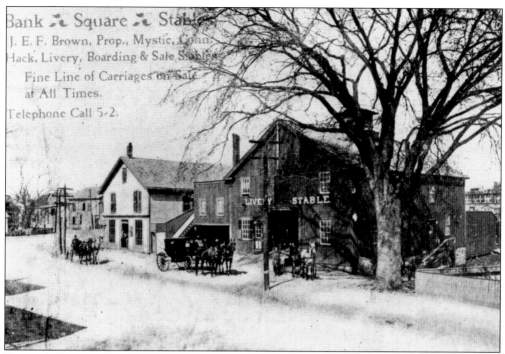

BROWN'S LIVERY STABLE, C. 1895. A pen-and-ink drawing on this trade card for the Brown livery stable depicts Water Street at Bank Square as a busy, but not congested, part of town. The light-colored building has been remodeled but still stands at the corner of West Main Street across from the Chelsea Groton Savings Bank. A real-estate agency occupies the livery stable site. Traffic backups are now common at this corner, especially during the summer.

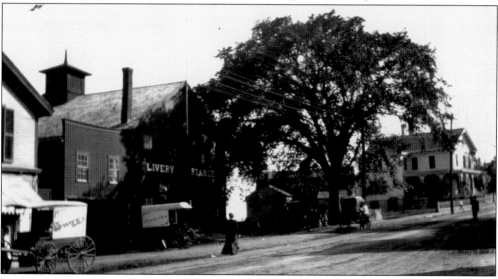

BROWN'S LIVERY STABLE, C. 1905. The large elm tree in front of the livery stable on Water Street was known as Brown's Elm. In 1917, Helen May Clarke wrote in her diary that she liked the livery stable, but her mother told her that it was not a place for ladies. Clarke went there anyway and reported that the proprietor had "buggies, carryalls, surreys, funeral haks [sic] and a hearse." (Courtesy H. B. Lamb.)

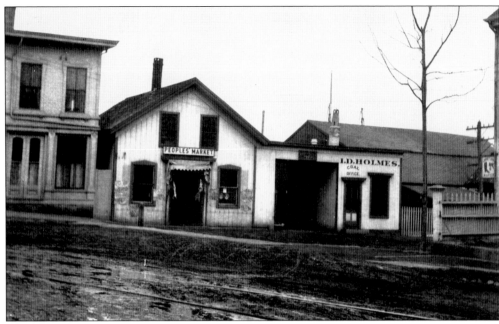

THE PEOPLES' MARKET AND THE HOLMES COAL COMPANY, C. 1912. These businesses were still open as recently as 1930, but under different management. They were on the corner of East Main Street and Holmes Street at Nos. 1 and 3. Capt. Jeremiah Holmes, one of the early settlers in Mystic, lived across the street, and a corner of his house is visible at the right. (Courtesy the Indian and Colonial Research Center.)

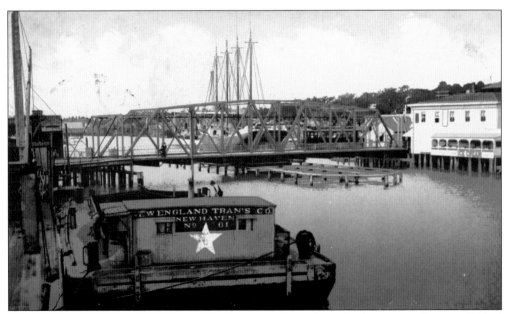

THE MYSTIC RIVER AND MYSTIC BRIDGE, C. 1908. A Holmes Coal Company barge is docked north of the bridge, and a large sailing vessel can be seen at the Gilbert Transportation Company shipyard just south of the bridge. Ebenezer Morgan's confectionery and ice-cream shop is across the river next to the bridge. That building still stands, and ice cream is still sold there.

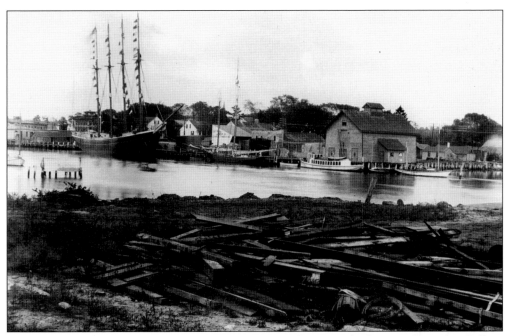

LOOKING ACROSS THE MYSTIC RIVER, C. 1904. This view looks east from the Gilbert Transportation Company shipyard just south of the bridge. Note the piles of timber used in the building and repairing of vessels. Across the river is the Cottrell Lumber Company and perhaps a Gilbert vessel tied up at the dock. (Courtesy the Indian and Colonial Research Center.)

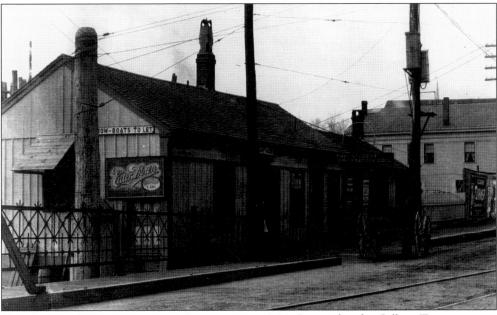

THE GILBERT TRANSPORTATION COMPANY, C. 1906. Pictured is the Gilbert Transportation Company's first office building, on West Main Street just west of the bridge. In the shipyard, at the rear of the office, the company built and repaired four-masted schooners and launched them right there into the Mystic River. Steamboat Wharf now stands in this location. (Courtesy the Indian and Colonial Research Center.)

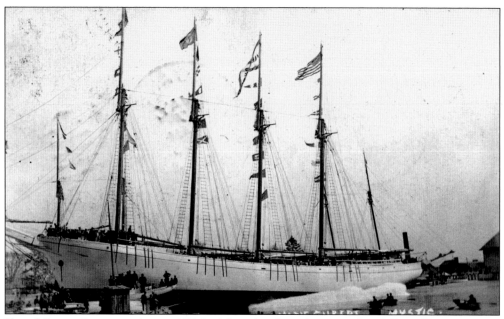

THE *MARIE GILBERT*, APRIL 1906. After this launching at the Gilbert Transportation Company, Capt. Mark Gilbert, one of the two owners of the company, hosted a catered luncheon for 500 guests in honor of the occasion. This was the first schooner built by the company in Mystic and was named for Gilbert's wife.

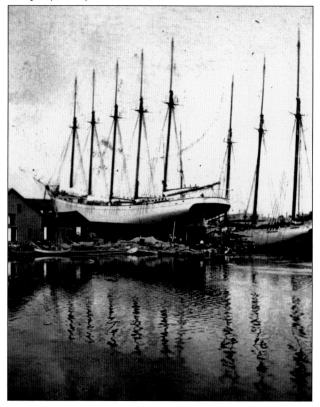

THE *ELVIRA BALL*, AUGUST 1907. This five-masted schooner was the second and last vessel built at the Gilbert Transportation Company's Mystic shipyard. It was a fast coastal schooner but sailed for only two years before being lost at sea in 1909. The company lost many of its vessels at sea under suspicious circumstances.

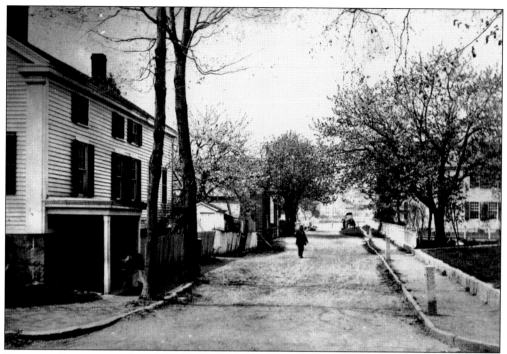

FORSYTH STREET, C. 1910. The Mystic River can be seen in the background from the corner of Willow and Forsyth Streets. The canopy of tree branches no longer shades the street, but the buildings are still standing. George E. Tingley may have taken this picture, as he lived right around the corner on Willow Street.

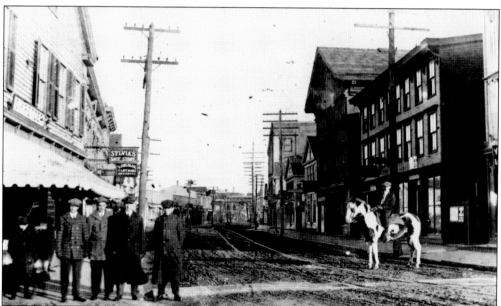

WEST MAIN STREET, C. 1915. Boys stand in front of Kretzer's Variety Store, on the corner of West Main and Pearl Streets. George A. Fish sits on his pinto pony, and behind him is Toy Lem's Chinese Laundry. Down the street are the Mystic Bowling Alley and the trolley switch near Gravel Street.

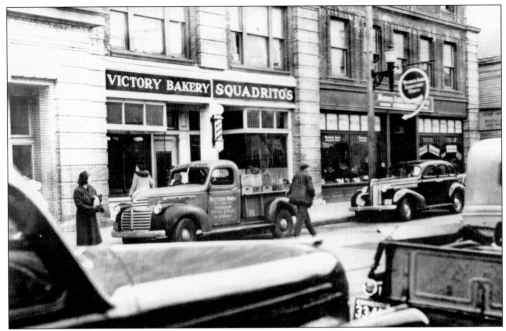

THE GILBERT BLOCK, C. 1935. Envisioning a bright future in Mystic, the Gilbert Transportation Company built this large building on West Main Street in 1909. The first floor was rented out to merchants. This picture shows the west end of the building with three retail stores. A sign to the far right welcomes visitors to Mystic and offers free parking.

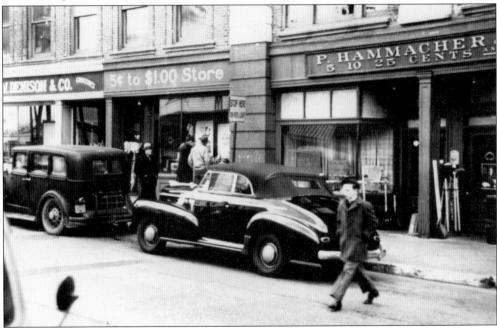

THE GILBERT BLOCK, C. 1935. The other half of the Gilbert Block, east toward the river, housed additional retail business. I. W. Denison's general store had been in business in Mystic since the turn of the century and had recently moved into the new building. The P. Hammacher five-and-dime store opened right after the construction was completed.

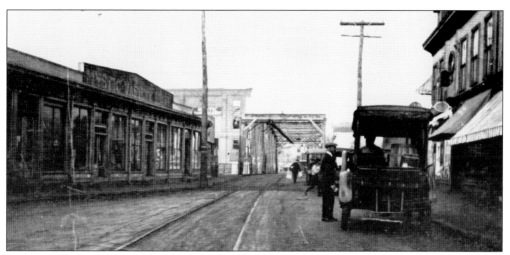

East Main Street, c. 1915. In this view looking toward the bridge on East Main Street, the T. H. Newbury store is on the right and Agnes Park's Mystic Variety Store is on the left. The bridge has been reinforced to carry the trolleys, and the large brick Gilbert Block rises above the bridge on the left.

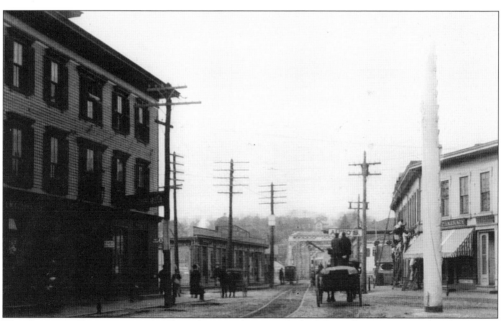

The Liberty Pole, c. 1915. The Liberty Pole, a symbol of the village's support for the Union army during the Civil War, was raised on the west side of the river near the bridge in 1862. In 1876, it was moved to its present location in Hoxie Square (shown here) after a dispute with the owner of the original site. The Hoxie Hotel is to the left. (Courtesy the Indian and Colonial Research Center.)

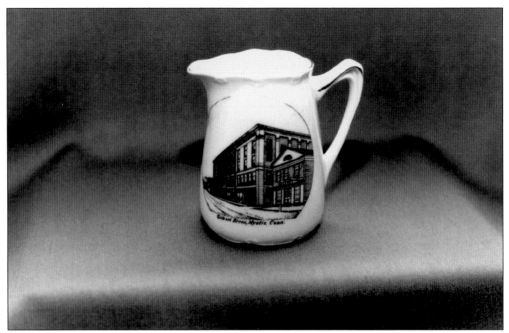

SOUVENIR CHINA, C. 1900. At the turn of the century, the T. H. Newbury store commissioned a company in Germany to manufacture china dishes with pictures of local scenes imprinted on each piece. Newbury's sold them as popular souvenirs. This cream pitcher depicts the Gilbert Block. (Courtesy Judy Hicks.)

SOUVENIR CHINA, C. 1900. The T. H. Newbury store commissioned unusual and fancy pieces. This cookie plate has a picture of the Mystic and Noank Library imprinted within the curled-up corners. Small plates, sugar and creamer sets, and also larger pieces have survived over the years. (Courtesy Judy Hicks.)

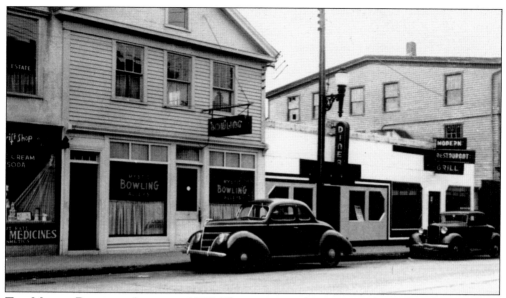

THE MYSTIC BOWLING ALLEY, C. 1935. This was a popular meeting place where local bowling leagues competed. In the 1960s and 1970s, mothers watched their children bowl in the afternoons after school. These original 19th-century buildings have been damaged by fires over the years but have been rebuilt and remodeled. The bowling alley building now houses specialty shops.

THE TIFT BUILDING, C. 1935. Samuel Buckley built this large building on the north side of West Main Street in the late 1870s for retail business. It was known as the Buckley Building until 1931. In that year, Buckley conveyed the property title to his wife, Anna Mallory Tift, and it then became known as the Tift Building. The property remained in the family until 1978.

THE HOTEL MYSTIC, C. 1930. The Hotel Mystic was located at the corner of Cottrell and East Main Streets in Hoxie Square, a site where various hotels have been in business since at least 1860. The word "Mystic" had become important in marketing by the date of this picture. The present owners of the hotel have recently restored the building to its original design.

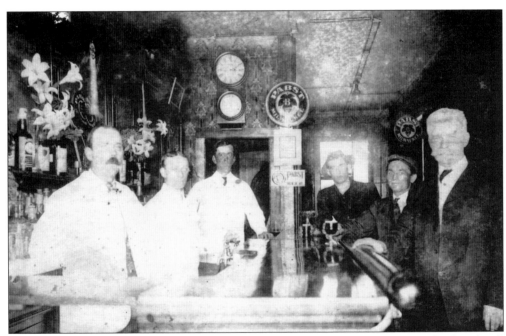

THE INTERIOR OF THE HOTEL HOXIE, C. 1908. At the turn of the century, the hotel still included "Hoxie" in its name. Here in the bar, the bartenders in their formal jackets are ready to serve. It was a small bar that served local patrons along with the traveling salesmen who had business in the area. Proprietor Archie L. MacLaughlin stands to the right. (Courtesy Barbara Stefanski.)

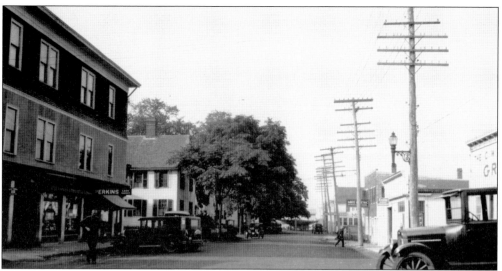

COTTRELL STREET, C. 1925. The Campbell Grain Company and Davis Electric are on the right, and farther down is the Cottrell Lumber Company. The Odd Fellows building is on the left, along with the Haley house, which was taken down and replaced by the Hoxie firehouse. The Hoxies moved to a new building in the early 1990s, and their former firehouse is now a private home. The Odd Fellows hall is still in operation.

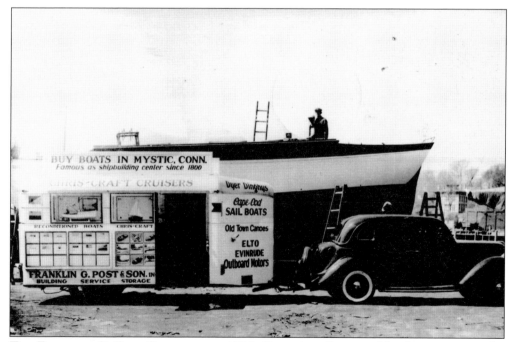

THE FRANKLIN G. POST SHIPYARD, C. 1930. Post originally opened his business across the river in 1914 and moved to Cottrell Street in 1923. His "on the road" advertisement trailer notes that Mystic has been "famous" as a shipbuilding center since the 1800s. The Post yard was known for fine yachts and fishing boats as well as for the high-speed rescue and patrol boats that it built during World War II. The business continued into the 1950s.

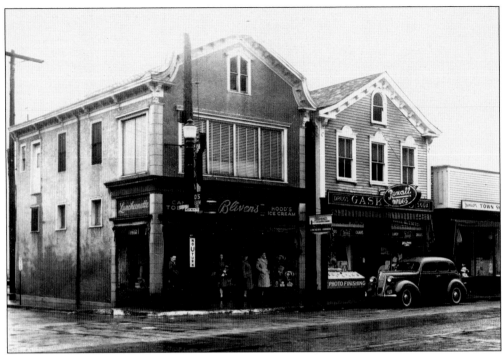

WEST MAIN STREET, C. 1940. These buildings still stand on the corner of Gravel and West Main Streets. They were erected in late 19th century on land once owned by Albert Wolfe, who lived around the corner on Gravel Street. He owned many of the properties on West Main Street and leased land to entrepreneurs, who would then build their stores. Gaskell's Rexall Drug opened as a pharmacy in 1858.

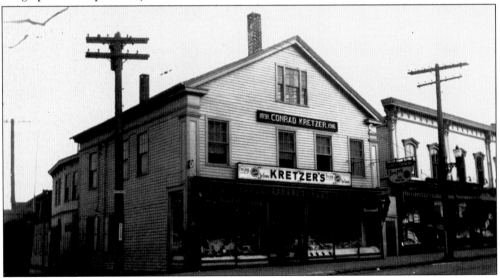

WEST MAIN STREET, C. 1940. Conrad Kretzer started his newspaper and variety store in 1881 on the corner of Pearl and West Main Streets. The building had been built c. 1850 on land owned by Albert Wolfe. Lucy Kretzer took over the business in 1909 and sold it in 1949. Various owners continued to run a newspaper store here until the late 1990s. To this day, local people still refer to the building as Kretzer's.

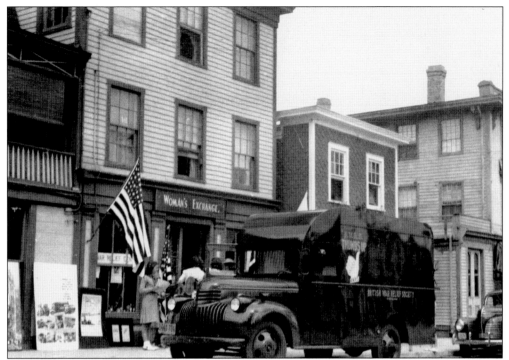

WATER STREET, C. 1940. These buildings at Bank Square were taken down in 1953 to make way for a new bank building. The site of the Woman's Exchange is now part of the bank's parking lot. To the left is the Seth Burrows house, built in 1815. The age of the house was discovered when it was being torn down, and it is now restored and at the Mystic Seaport Museum.

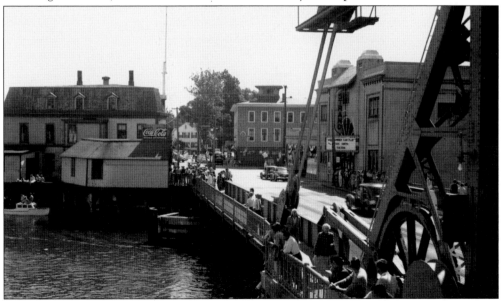

MYSTIC DAY, AUGUST 1949. People are gathering downtown to celebrate the Stonington tercentennial. The newsstand next to the river and the Newbury Block are on the left. The Strand Theater, built out over the river to the right, is featuring *Any Number Can Play*, starring Alexis Smith. Noyes' Dry Goods and Kinney Jewelers are decorated for the celebration.

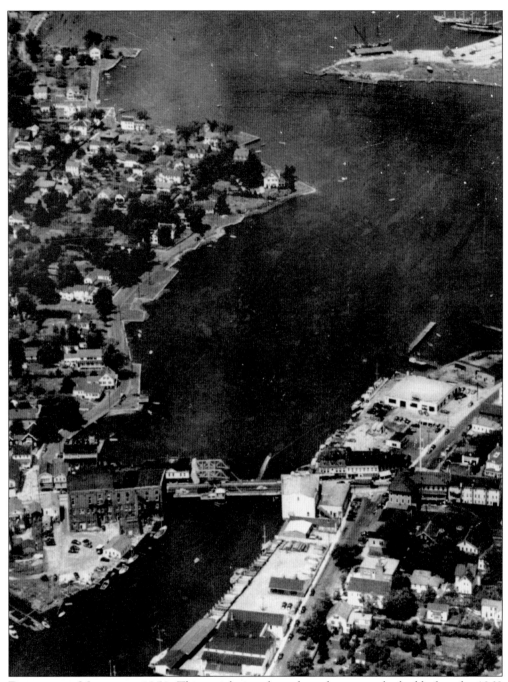

DOWNTOWN MYSTIC, C. 1950. This aerial view shows how downtown looked before the 1960 fire. To the south of Santin Chevrolet (the large building in the center right) is the Newbury Block, and across the street are Kinney Jewelers, Noyes' Dry Goods, and the Strand Theater. All of these were lost in that big winter fire, which changed the appearance of downtown Mystic. An aerial view today would show one store rebuilt on the south side of East Main Street and a restaurant and condominiums on the north side of the street.

Five

ALONG AND ON THE RIVER

THE UNION BAPTISM IN MYSTIC RIVER, 1842. This Barber engraving depicts a baptism scene during a religious revival led by Rev. Jabez Smith Swan. Gravel Street is in the background, and the Mariners Free Church is in the upper left. This was the only church for the villages at that time. Built in 1828 by private subscriptions, it was open to any who were Christians "in good standing." Different denominations used the church for their services. (Courtesy Carol W. Kimball.)

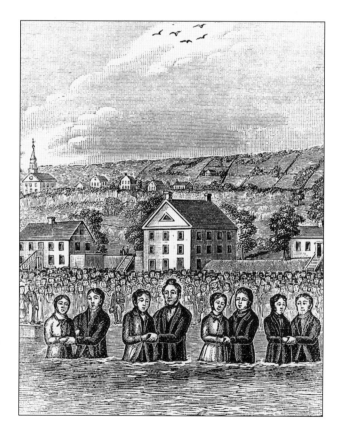

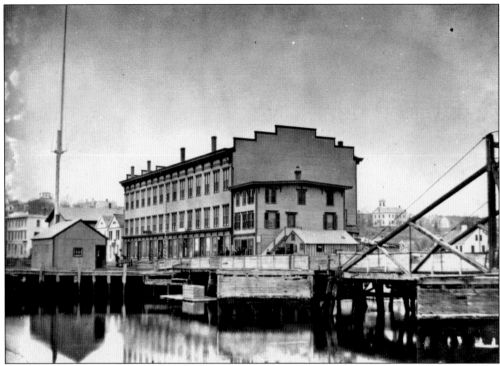

THE MYSTIC RIVER BRIDGE, C. 1865. The first Mystic River bridge, built in 1819, was a toll bridge. It was rebuilt in 1854 by Henry Latham and was subsequently purchased by the towns of Stonington and Groton. The bridge became public and free, allowing the residents of Mystic Bridge and Mystic River to mingle more readily. Central Hall rises behind the bridge, and the Mystic Academy sits up on the hill to the right. (Courtesy H. B. Lamb.)

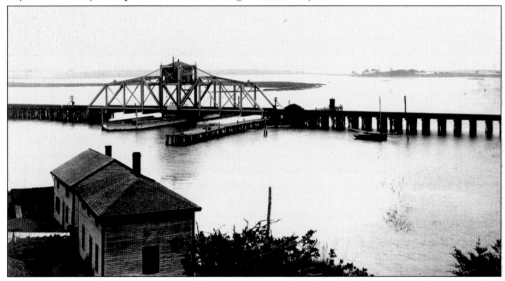

THE RAILROAD BRIDGE, C. 1900. The steam-operated railroad bridge, as seen downriver from Fort Rachel, was built in the late 1880s. The signal station was some distance down the tracks, but the bridge was operated from the tower in the center. This bridge was replaced in 1919, and the current bridge replaced that one in 1981. (Courtesy H. B. Lamb.)

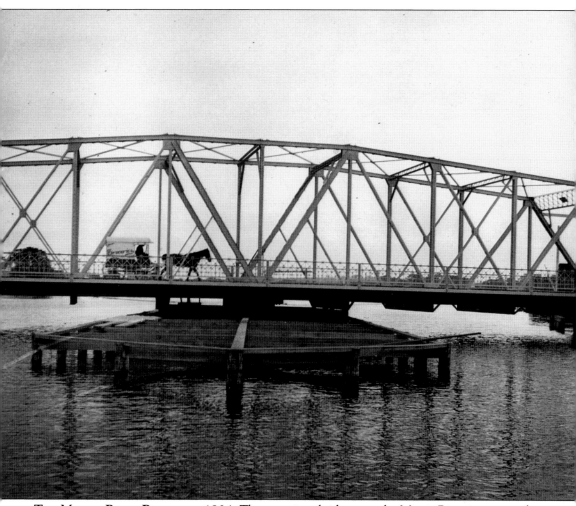

THE MYSTIC RIVER BRIDGE, C. 1904. The great iron bridge over the Mystic River was opened in 1866. It was considered by some to be the best bridge in Connecticut. However, there was concern about the effect of traffic on such a structure. John Roebling described the problem in his book *Memoir of the Niagara Falls Suspension Bridge and Niagara International Bridge:* "I will state here that in my opinion a heavy train, running at a speed of twenty miles an hour, does less injury to the structure than is caused by twenty heavy cattle under a full trot. Public processions, marching to the sound of music, or bodies of soldiers keeping regular step will produce a still more injurious effect. . . . The best built suspension bridge, as well as all kinds of wooden or iron structures, not excepting tubular bridges, will suffer from this cause." This explains why the towns erected a sign admonishing travelers: "Trot Not On This Bridge." The sign was later changed to "Walk Your Horse." (Courtesy the Indian and Colonial Research Center.)

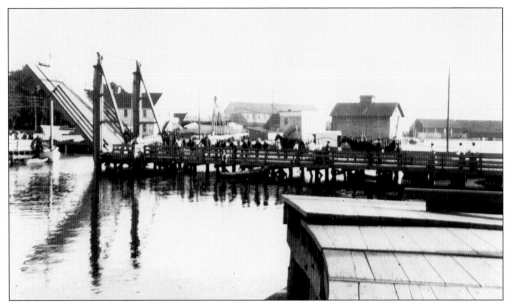

A Temporary Bridge, c. 1904. This bridge was built to accommodate carriage and pedestrian traffic while the iron bridge was being strengthened to support the weight of the trolleys. It was located a short way south of the bridge extending from the rear of the Gilbert Block to the Cottrell Lumber Company (now Mystic River Park) and was in use for only three months. (Courtesy the Indian and Colonial Research Center.)

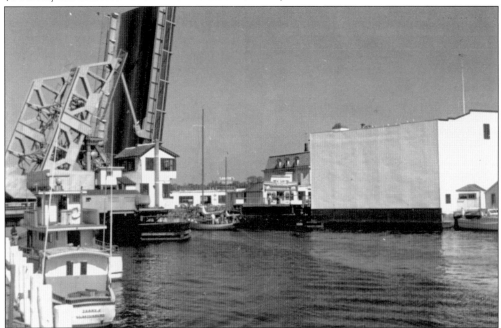

The Bascule Bridge, 1960. The unique Brown balance-beam light bridge opened with much fanfare in 1922. Today, it continues to open and close (on a regular schedule in the summer season and on demand during the rest of the year) so that boats may pass through. When the bridge whistle blows, residents know that traffic will soon be backed up downtown. The former Strand Theater is to the right. (Courtesy Daniel B. Fuller.)

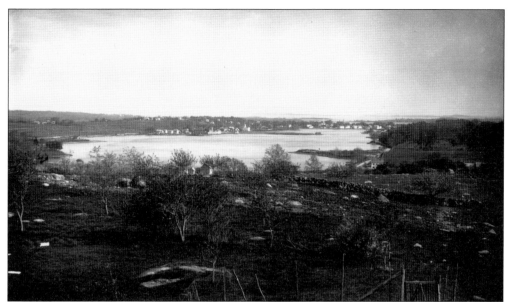

A VIEW OF MYSTIC AND THE RIVER, C. 1910. Looking downriver from atop the hill where the Mystic Oral School stood, one saw a typical New England landscape. Stone walls and rocky fields sit above the turns of the river with the villages on either side. Out near the mouth of the river, a little of Noank and Masons Island can be seen.

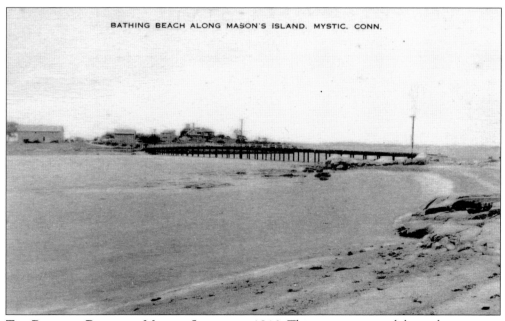

THE BATHING BEACH AT MASONS ISLAND, C. 1910. This picture postcard shows the causeway that connects the two parts of the easternmost finger of Masons Island. Masons Island Yacht Club is now on the land from which this photograph was taken, and the Edmundite Apostolate Center on Ender's Island is seen in the center background.

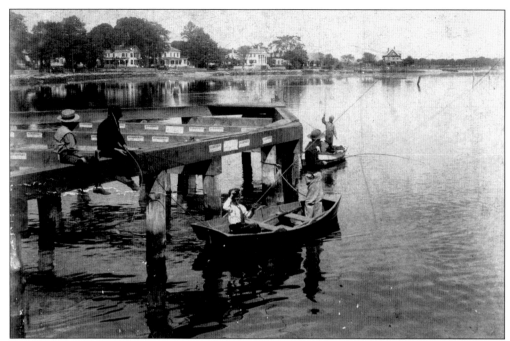

FISHING FROM THE BRIDGE, C. 1915. The turntable of the 30-foot-wide Mystic iron bridge made a good fishing spot. These well-dressed boys are fishing in more formal attire than what would be worn today. It is a calm afternoon on the river, and the view includes Gravel Street and on north up along River Road.

THE MYSTIC RIVER, C. 1910. This view looking downriver includes two ladies and a child sitting on the rocks at Fort Rachel. Out beyond the railroad tracks is what was then called Pine Hill. It is now known as Masons Island. The rocky outcropping seen on the island was all quarried away. (Courtesy the Indian and Colonial Research Center.)

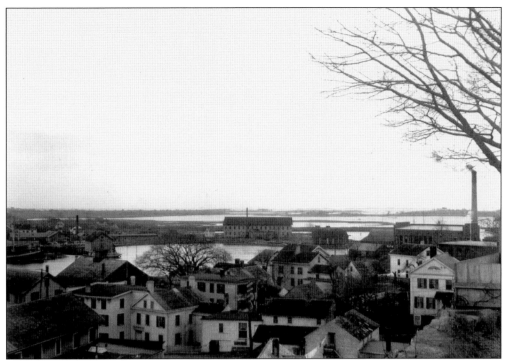

THE MYSTIC RIVER SOUTH OF THE BRIDGE, C. 1910. This picture was taken from atop Baptist Hill. The houses in the center foreground stand where the Chelsea Groton Savings Bank parking lot is located today. The building in the center background was Allen Spool and Printing Company. The Groton and Stonington Trolley Company's power plant, with its smokestack, is seen at the right. (Courtesy the Indian and Colonial Research Center.)

THE MYSTIC RIVER NORTH OF THE BRIDGE, C. 1910. Looking north up the river, this view shows River Road in the left background. The house on the point is still a landmark. Across the river, on the east side, is Elm Grove Cemetery. Capt. Elihu Spicer's obelisk in the cemetery was used as a point of navigation when the channel of the river was first charted. (Courtesy H. B. Lamb.)

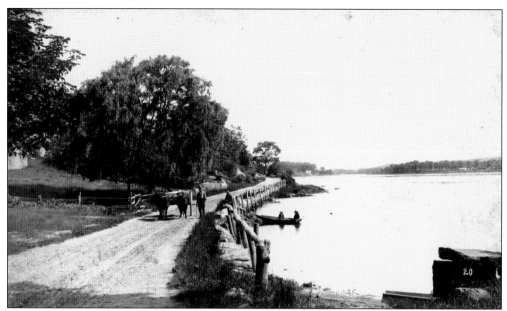

RIVER ROAD, C. 1900. A yoke of oxen pauses for a rest on lower River Road as the driver chats with the man at the side of the road and with the two boys in their rowboat down on the river. (Courtesy H. B. Lamb.)

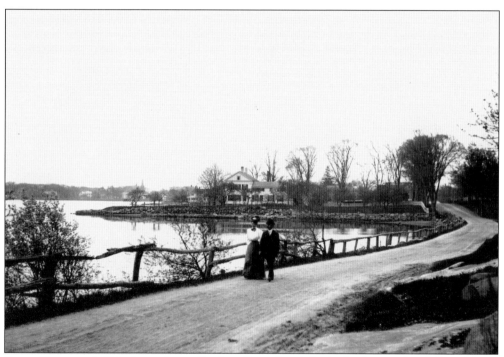

RIVER ROAD, C. 1910. A couple strolls along River Road. In the background, at 2 Starr Street, is the house that Horace H. Clift, a Mystic carpenter, built *c.* 1850. In 1891, the property was sold to Charles H. Davis, a well-known landscape painter and one of the founders of the Mystic Art Association. (Courtesy H. B. Lamb.)

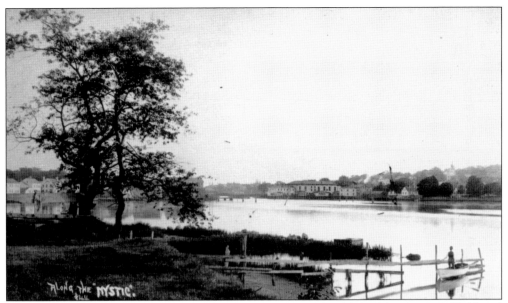

ALONG THE MYSTIC RIVER, C. 1890. A striking postcard published by the Scholfield and Tingley Photography Studio pictures a quiet day on the Mystic River. A young man ties up his boat on a point of land on the east bank, where the Mystic Seaport Museum is located now. (Courtesy Judy Hicks.)

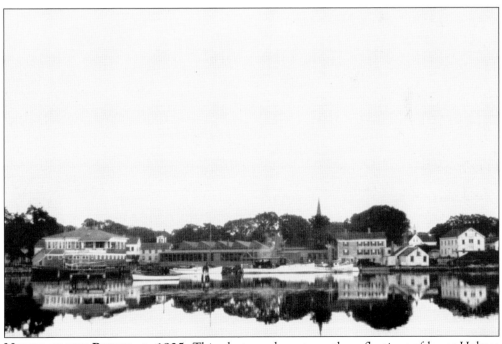

NORTH OF THE BRIDGE, C. 1925. This photograph captures the reflections of lower Holmes Street buildings on the still waters of the Mystic River. At the left is the rear of the Mystic Club, and at the right is the Mallory sail loft that was later moved to the Mystic Seaport Museum.

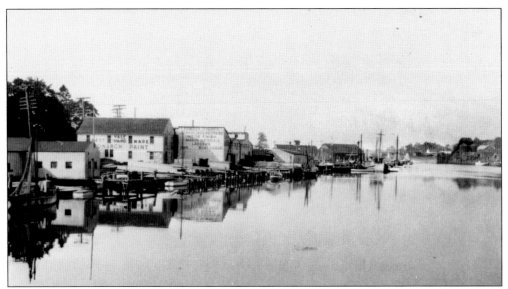

SOUTH OF THE BRIDGE, C. 1925. Pictured here are the reflections of the Cottrell Lumber Company buildings on the east side of the river. To the south is the Post shipyard. The docks along Water Street on the west side also reflect on the water, and beyond them are the trolley car buildings.

HOLMES STREET COVE, C. 1910. Boats were kept in this little cove at the intersection of Holmes and Bay Streets. There was access to the river under a wooden bridge. The house in the background has been remodeled and enlarged but still has the wraparound porch. (Courtesy the Indian and Colonial Research Center.)

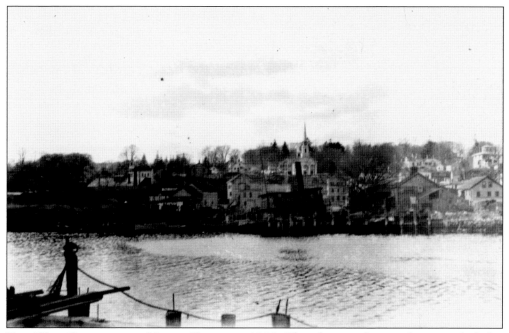

THE WEST BANK OF THE MYSTIC RIVER, C. 1925. This photograph was taken on a dark day on the river, looking from just below the bridge on the east side. The Union Baptist Church and Portersville Academy sit high up the hill. Below are the docks on Water Street.

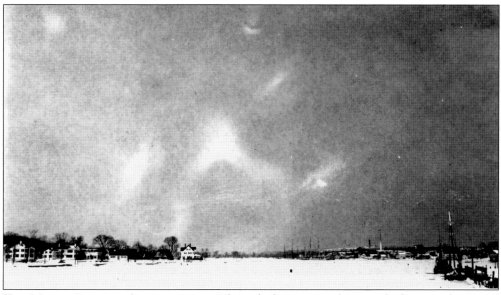

THE MYSTIC RIVER IN SNOW, C. 1930. Through the snow in this view looking north, Gravel Street and Appelman's Point are seen on the left. The Holmes Coal Company docks and the present site of the Mystic Seaport Museum are on the right.

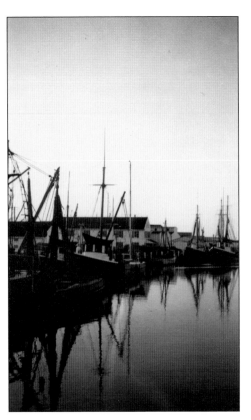

FISHING BOATS ALONG COTTRELL'S WHARF, c. 1925. A fleet of fishing boats is tied up along Cottrell's Wharf on the east side of the Mystic River. Rafted together, they possibly belong to the Stonington fleet and are taking protection in the Mystic River from forecasted foul weather.

GRAVEL STREET, C. 1930. This view from the east bank of the Mystic River shows the Lathrop Engine Company's first building next to the river. Beyond it is the company's second building, a large brick structure. This piece of land, which juts out into the river on Gravel Street, is still there but not with the interesting light and pole.

Six

HOUSES AND
THEIR HISTORY

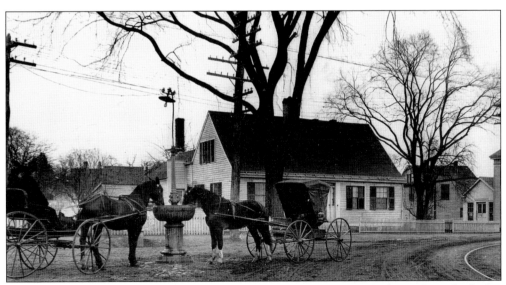

THE PEACE GRANT HOUSE, WEST MAIN STREET, C. 1910. Capt. Ambrose Grant built this Cape Cod–style house in the early 1800s at Bank Square between Pearl and Bank Streets. His descendants lived in the house until it was razed in 1924. The block is commercial now, with Mystic Pizza to the west, a bank in the middle, and a stucco building on the corner. (Courtesy the Indian and Colonial Research Center.)

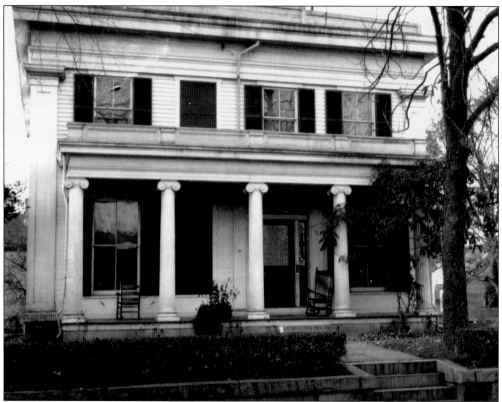

No. 14 Willow Street, c. 1925. Capt. Peter Forsyth built this Greek Revival house in 1831. In 1842, he was part owner and master of the sloop *J. D. Fish* and, in 1845, of the schooner *Empire*. From 1846 to 1851, he ran a shipyard on the east side of the river opposite Appleman's Point. That was later the location of the Charles Mallory and Sons shipyard.

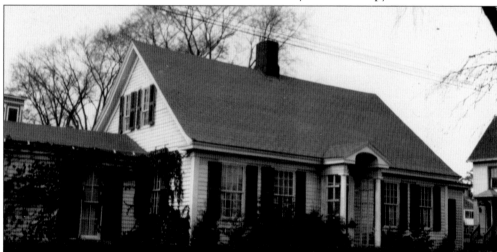

No. 24 Willow Street, c. 1925. George Haley, a shipbuilding investor, built this Cape Cod–style home in 1806. In 1833, he sold it to his nephew Stephen Woodward for "$2,000 and all the love and consideration of a good friend." Stephen's mother, Hannah, was George Haley's sister. She lived across the street in a house that Capt. Perez Woodward built in 1808.

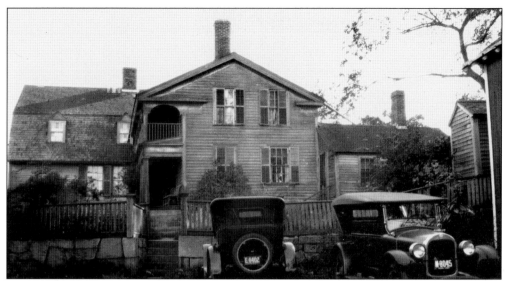

No. 32 Water Street, c. 1925. Built by Capt. Daniel Packer in 1758, this Colonial house is now a restaurant, the Captain Daniel Packer Inn. Packer, one of the early Mystic shipbuilders, built his home on land that had been granted to his grandfather John Packer in 1651. It was part of a land grant of 150 acres on "Mystic Hill."

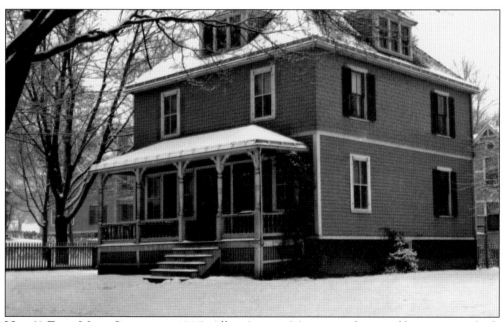

No. 62 East Main Street, c. 1925. Allen Avery, a Mystic merchant and businessman, built this house in 1892. Upon completion of the house, he sold it to Henry Miner, a ship's carpenter. Photographer M. Josephine Dickinson lived here in the early 1920s. Many of the photographs in this book are from her collection, including this one. The house style is Colonial Revival with Queen Anne influences.

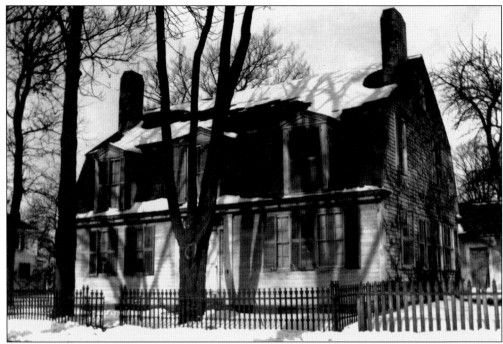

No. 21 East Main Street, c. 1920. Hon. Asa Fish, a prominent Mystic merchant and citizen, built this gambrel-roof house in 1824. His store, which served the needs of fishermen and sailors, was nearby just south of the bridge. Fish also served in both local and state offices. He and his wife were charter members of the Mystic Congregational Church, located right up the street from their home.

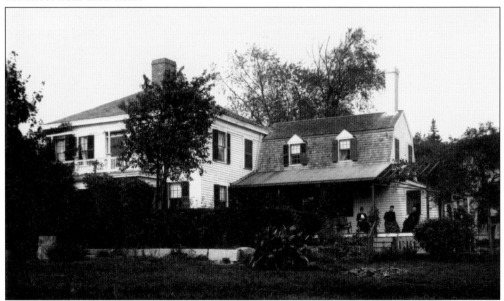

No. 126 High Street, c. 1910. Looking down over Portersville on the west side of the river, this house was built in 1811 on Burrows land and became known locally as the Tift house. In 1816, the Amos Tift family purchased the house, and it stayed in that family until 1955, when boatbuilder Ernest F. Post bought the property. (Courtesy H. B. Lamb.)

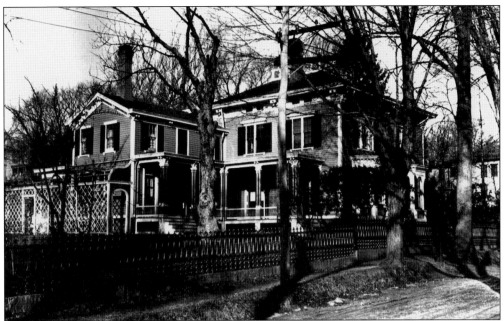

NO. 9 ELM STREET, C. 1900. This Italianate style home was built *c.* 1855 for Leonard W. Morse and his wife, Bathsheba. Morse acquired the land from Amos Clift and his mother, Thankful Clift, for $65. In 1912, Albert L. Pitcher, publisher of the Mystic Times newspaper lived here. (Courtesy the Indian and Colonial Research Center.)

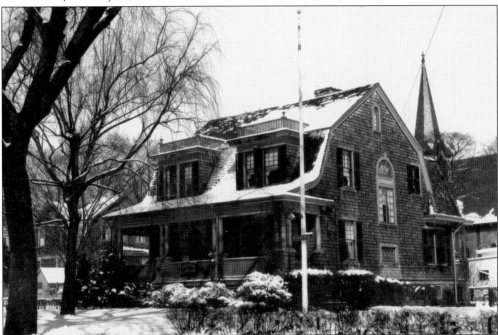

NO. 31 EAST MAIN STREET, C. 1930. This Shingle-style house still stands west of St. Patrick's Community Hall and looks very much as it did when it was built in 1900. In the 1930s, it became an inn. The spire of the Methodist church can be seen in the background. That church was destroyed in the 1938 hurricane.

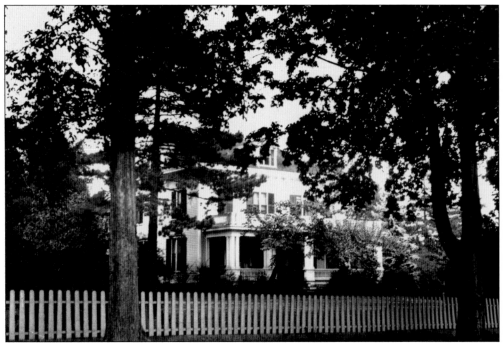

No. 28 New London Road, c. 1925. Gurdon Allyn built this home in 1866 on the site of the Joseph Packer Tavern, which was built in 1767. The tavern faced the highway running from Groton to the Mystic River. Allyn used many of the old timbers from the tavern, and they can still be seen today. The house remained in the Allyn family until 1944.

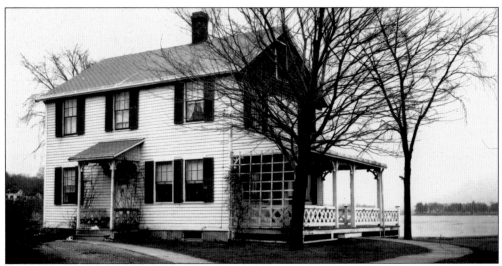

No. 11 Park Place, c. 1925. In 1890, this house was owned by Eliza and Flavius Cheney. Flavius Cheney sold school supplies and owned the Cheney Globe Company. Before this house was built, the land was the site of the Charles H. Mallory shipyard and later the Forsyth and Morgan shipyard. Recently, the house was taken down and replaced by a new home.

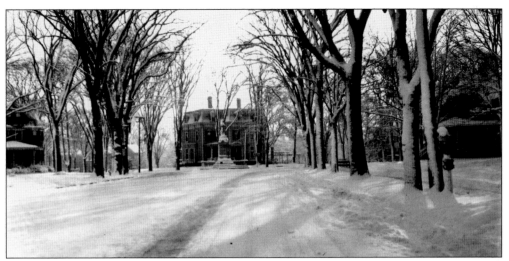

No. 25 Broadway, at East Main Street, c. 1930. Nothing of this scene remains today except the Civil War monument. Commercial buildings have replaced all three houses, and the large elm trees went down in the 1938 hurricane. The house in the center was built between 1869 and 1879 on land owned by Charles Mallory and was razed in the 1940s.

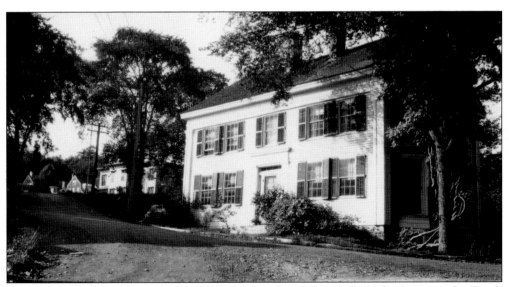

No. 2 New London Road, c. 1925. Capt. Jonathan Wheeler built this house in the Greek Revival tradition on Packer land in 1810. Wheeler was an officer and leader during the War of 1812. In 1829, Lyman Dudley, a prosperous blacksmith and shrewd businessman, bought the property and established his blacksmith foundry across the street.

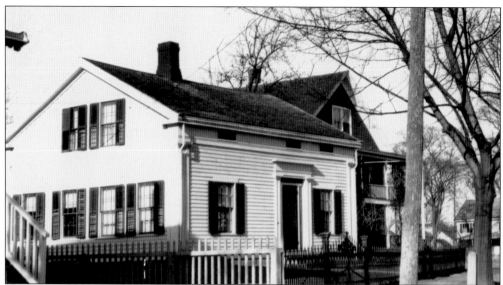

No. 61 Denison Avenue, c. 1925. Ebenezer Morgan built this small house for his mother, the widow of Capt. Stephen Morgan, in 1853. He moved out of town, but his two sons stayed in Mystic and opened a confectionery and ice-cream business, Morgan's Riverside Garden, right beside the river on West Main Street. That building has been an ice-cream shop under different management over the years and still is one today.

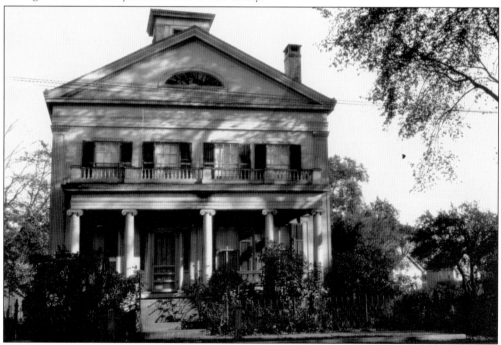

No. 35 Willow Street, c. 1925. Capt. Perez Woodward built a dwelling here in 1809, and in 1828, Charles Mallory incorporated some of that structure into the "mansion" he erected on the site. In December 1816, Mallory, a young almost penniless sail maker, set out on foot from New London headed for Boston when he stopped in Mystic. By midcentury, he was one of Mystic's wealthiest men. The house still belongs to the Mallory family.

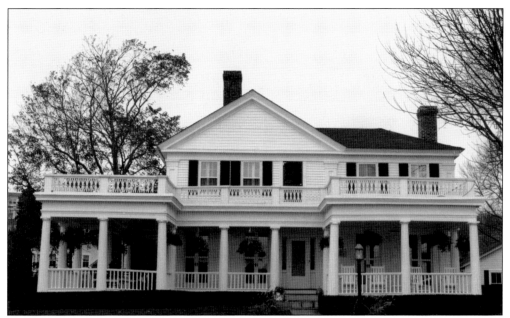

No. 21 Gravel Street, c. 2000. This house was built in 1840 by Amos Clift. Dorothy Vinal, niece of E. E. Dickinson, an Essex witch hazel manufacturer, lived here in the 1920s. Her father, T. H. Dickinson, also made witch hazel, but here in Mystic. When the families got together, the floor-to-ceiling windows in the front parlors would be opened onto the veranda and the party would begin.

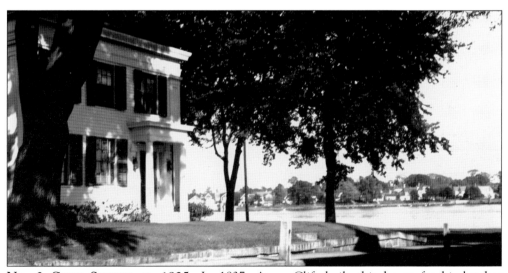

No. 2 Clift Street, c. 1925. In 1837, Amos Clift built this house for his brother Capt. Waterman Clift on land that had belonged to their parents, Amos and Thankful Clift. Captain Clift commanded several sailing vessels and was also a harbor pilot in Apalachicola, Florida. It is believed that the wings on the north end of the house were assembled in 1837 from three smaller buildings.

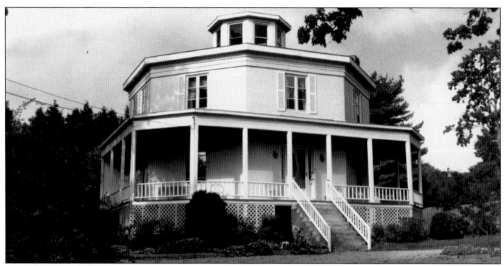

No. 8 West Mystic Avenue, c. 1995. Mystic merchant Albert G. Stark built this unusual octagon house in 1850 next-door to the house of his brother, Capt. Henry S. Stark. A smart businessman, Albert was owner of a general store by his early 20s. Unfortunately, like his brother, he too suffered an early death—his brother at age 37 and he at age 29. His wife remained in the house and remarried in 1863.

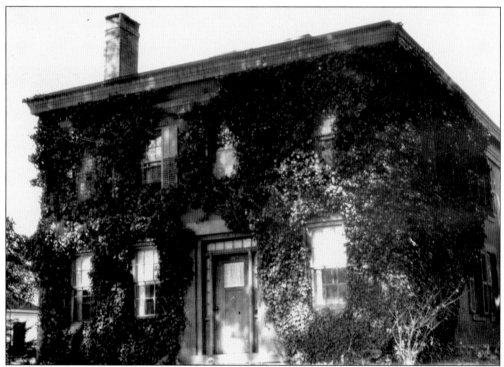

No. 35 Church Street, c. 1925. One of three brick houses in Mystic in the mid-19th century, this home was built in 1851 for Capt. Joseph W. Holmes. He commanded 80 trips around Cape Horn, 3 around the Cape of Good Hope, and 3 around the world. It is thought that local carpenter Amos Clift did the interior work and that William Kenney, a next-door neighbor, did the masonry.

No. 58 East Main Street, c. 1925. Dr. John Bucklyn Jr. built this house in 1890 right in back of his father's Mystic Valley Institute on Lincoln Avenue. He and his brother, also a physician, advertised at the turn of the century that they held office hours here from two to three in the afternoons and from seven to eight in the evenings. The house shows Italianate influences.

No. 40 East Main Street, c. 1910. George Grinnell built this large Victorian home *c.* 1890 at the intersection of Main Street and Broadway, which soon became known as "the Grinnell corner." He was bookkeeper for the Mystic Hardware Company. After that firm became the Standard Machinery Company, George Grinnell was listed as its secretary in the 1912 town directory. He retired shortly thereafter. The house was razed in the 1950s. (Courtesy the Indian and Colonial Research Center.)

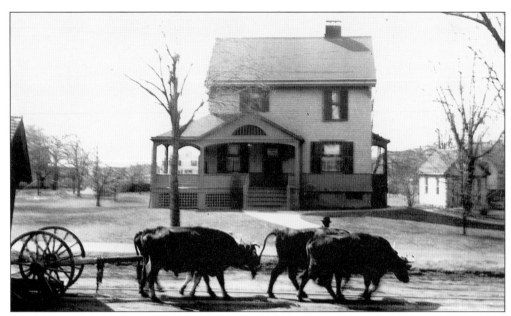

No. 38 East Main Street, c. 1900. Local architect John S. Rathbone designed this American Craftsman–style house in 1893 for Orin A. Wilcox, secretary of the Wilcox Fertilizer Company. Note the double yoke of oxen pulling an outhouse down the street. (Courtesy the Indian and Colonial Research Center.)

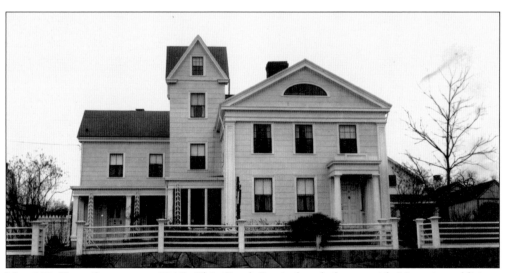

No. 193 High Street, c. 1945. This Greek Revival–style house with Victorian additions was built in 1838 for Capt. William Clift, commander of several Mystic schooners. The house stayed in the Clift family until 1918. In 1939, it was deeded to the Mystic Home, and in 1976, Noank Baptist Group Homes took it over as a residence for teenage girls.

Seven

AFTER THE SAILS

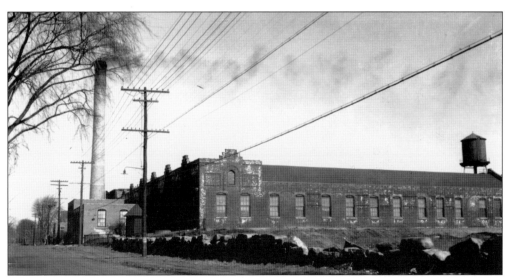

THE ROSSIE VELVET COMPANY, C. 1930. The Rossie Velvet Mill, on Greenmanville Avenue, was built in 1898 by the Mystic Industrial Company. Mystic investors had formed this company to attract manufacturing to the village. Rossie was a German company manufacturing fine velvet textiles. Four additions to the original building were necessary between 1902 and 1932. It is now owned by the Mystic Seaport Museum and is used for the photography and curatorial departments.

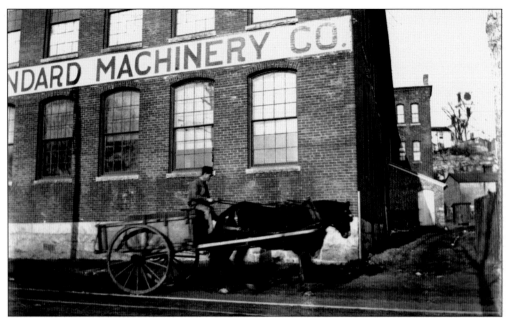

THE STANDARD MACHINERY COMPANY, C. 1925. The Randall brothers founded the Reliance Machine Company here in 1848. Until the Civil War, they manufactured cotton gins and related machines. That business failed, but the manufacturing of various types of machinery continued on this site. In 1904, Charles Wheeler rebuilt the original wooden building with brick. In the 1970s, it was converted into apartments, shops, and restaurants and became known as Factory Square.

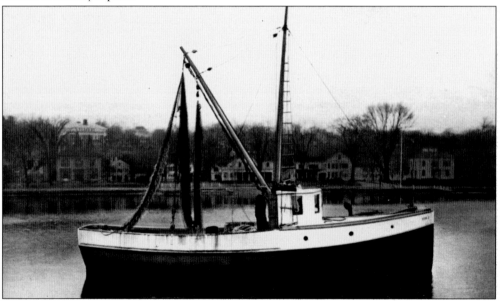

THE ROBERTA A. IN THE MYSTIC RIVER, C. 1935. James W. Lathrop started his marine gasoline engine company in his home on the west side of the Mystic River in 1897. His single-cylinder engine became so popular that he moved to Holmes Street in 1898. The *Roberta A.* is powered by a D-50 Lathrop diesel engine. Gravel Street is in the background, and the Mystic Academy is up on the hill.

THE MYSTIC BOARD OF TRADE'S MEMBERSHIP LIST, 1909. The members are listed in the printed program for their annual meeting, held in the Gilbert Block. (Courtesy Daniel B. Fuller.)

MEMBERS OF

MYSTIC BOARD OF TRADE

C. L. ALLEN	R. D. JUDD
H. H. ANDERSON	CONRAD KRETZER
F. W. BATTY	Rev. C. A. LEDDY
Dr. O. M. BARBER	G. S. B. LEONARD
THEODORE F. BAILEY	CHRISTOPHER MORGAN
PETER BRUGGERMAN	L. A. MORGAN
E. A. BLIVEN	J. W. McDONALD
E. E. BUCKLYN	W. L. MAIN
C. I. BARSTOW	WALTER C. MORGAN
A. W. BUTLER	EBENEZER MORGAN
BYRON BILLINGS	E. L. MOORE
J. E. F. BROWN	C. F. MITCHELL
JAMES COOPER	EDW. H. NEWBURY
O. A. COLBY	E. B. NOYES
A. R. CHAPMAN	H. B. NOYES
L. J. COBURN	C. C. POTTER
D. B. DENISON	A. L. PITCHER
FRED. DENISON	G. A. PERKINS
ALBERT DENISON	J. W. PHILLIPS
C. R. DONATH	ERNEST ROSSIE
C. H. ECCLESTON, Jr.	JOHN ROSSIE
CHAS. H. FOLEY	KUNIBERT ROSSIE
C. W. FOOTE	A. O. ROACH
ALDEN FISH	J. A. RATHBUN
C. E. GASKELL	T. H. RILEY
ELI GLEDHILL	E. B. SEAMANS
Dr. W. H. GRAY	Dr. W. S. SMITH
M. L. GILBERT	MANUEL SYLVIA
O. A. GILBERT	GEO. E. TRIPP
GEO. E. GRINNELL	B. E. THORP
GEO. E. GILCHRIST	GEO. E. TINGLEY
C. W. GILDERSLEEVE	CHAS. E. WHEELER
J. H. HOXIE	H. N. WHEELER
B. L. HOLMES	ROBT. P. WILBUR
C. D. HOLMES	ELIAS F. WILCOX
F. H. HINCKLEY	B. F. WILLIAMS
GEO. D. JOHNSON	C. F. WILLIAMS
L. E. WHITE	

Menu

⚜

OYSTER COCKTAIL

SPANISH OLIVES NEW ENGLAND CELERY

VERMICELLI CONSOMME

BROILED BLUEFISH, MAÎTRE D'GILBERT

FRENCH FRIED POTATO BALLS

Roman Punch

NATIVE ROAST TURKEY, OYSTER DRESSING

CRANBERRY SAUCE

MASHED TURNIPS MASHED POTATOES

CHARLOTTE RUSSE ECLAIRS

FROZEN PUDDING, BRANDY SAUCE

ASSORTED CAKES

ROQUEFORT CHEESE CRACKERS

BANANAS ORANGES NUTS

DEMI TASSE CIGARS

⚜

Caterer—C. E. DONATH

THE MYSTIC BOARD OF TRADE'S BANQUET MENU, 1909. This elegant banquet menu was for the board's annual meeting, held on February 16, 1909. A program with speakers and musical selections completed the evening. (Courtesy Daniel B. Fuller.)

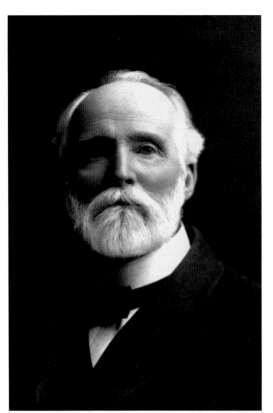

CAPT. DANIEL F. PACKER (1825–1904), c. 1890. Capt. Daniel F. Packer, a descendant of one of the earliest Mystic families and the youngest of 11 children, attended school in Mystic and later Buckley's Academy in Weston, Connecticut. Caught up in the gold rush fever of 1849, Packer spent three years in California, where he became interested in soaps. Upon his return to Mystic, he started making a product that he marketed as "Packer's All Healing Tar Soap."

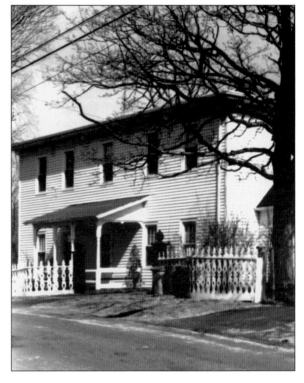

NO. 54 HIGH STREET, C. 1985. When Daniel F. Packer returned to Mystic in 1868, he built a home on the corner of High Street and the New London Road. It sat high on the hill, overlooking the Mystic River. He started his soap business here and hired young women from Mystic to wrap and package his soap bars. Such employment was considered genteel enough for ladies.

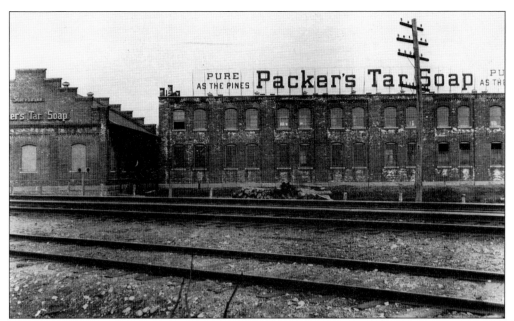

THE PACKER'S TAR SOAP FACTORY, C. 1915. The company outgrew Packer's home, and it moved to this building on Route 1 by the railroad station. The first building was built in 1902 for storage, and in 1906, a manufacturing facility was added. With a railroad spur to the main line, the soap could be distributed worldwide. The building has been renovated into office spaces and is called the Mystic Packer Building. (Courtesy the Indian and Colonial Research Center.)

PACKER'S PINE TAR SOAP, C. 1890. Packer's brown soap was wrapped in foil and packaged in an unusual green tin box with the standard of flags as its trademark. Cooper Industries bought the company in the 1960s and still manufactures the soap, but it is now packaged in paper.

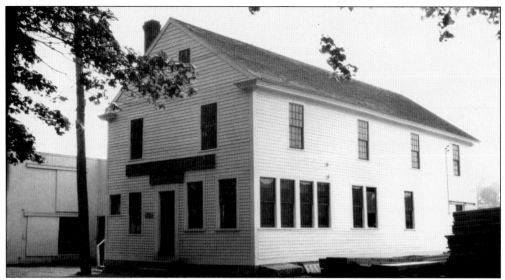

THE COTTRELL LUMBER COMPANY, C. 1925. Joseph Cottrell started this business in the early 1830s. It is believed to have been the earliest lumberyard in Connecticut and only the second one in New England. This was the main building, located on what was called Cottrell's Wharf. The company went out of business in the early 1990s, and the Mystic Fire District bought the property. The site is now a public park along the river.

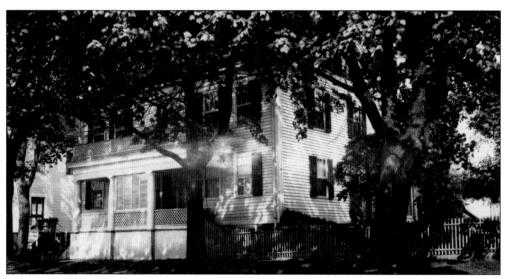

THE COTTRELL HOMESTEAD, C. 1925. In 1827, Joseph Cottrell built this house for his wife, Fanny Stanton, across the street from his lumberyard. It has Greek Revival features, including a four-columned porch. Later converted into apartments, it is part of the Cottrell property owned by the Mystic Fire District.

ELIAS WILCOX (1850–1928), c. 1890. Elias Wilcox captained the first menhaden steamer built in Mystic. This steamer, the *Annie L. Wilcox*, was built by Mason Crary Hill in 1878 for the Wilcox Fertilizer Company. In 1912, Wilcox was president of that firm. He lived in the Quiambaug section of Mystic.

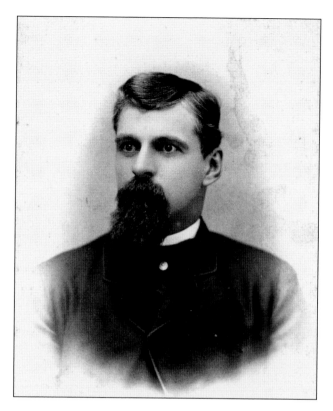

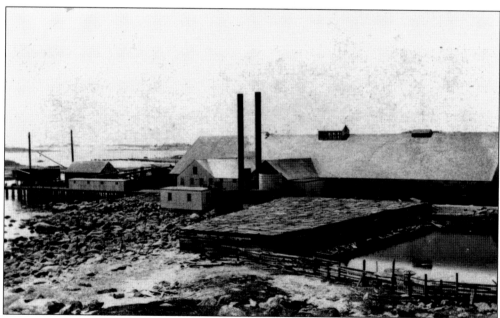

THE WILCOX FERTILIZER COMPANY, C. 1925. This plant was located on Latimer Point and processed menhaden fish for fertilizer. The company was a very important employer in Mystic, but downwind neighbors were not too sympathetic at times. The company's general office was on West Main Street where Mystic Pizza is now. There was also an office in New London.

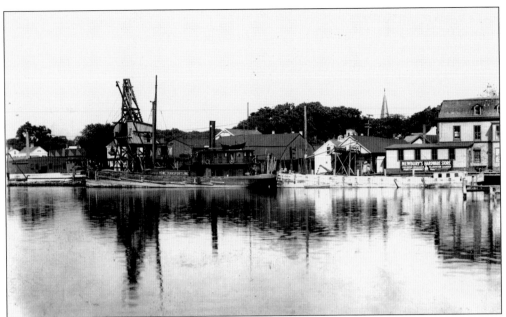

THE HOLMES COAL COMPANY, C. 1900. Isaac D. Holmes founded the company in 1847, and it stayed in the family until 1920. It was located on Holmes Street along the river just behind the Newbury Block. In 1938, Santin Chevrolet opened on the property. Today, a restaurant and condominiums occupy the land. (Courtesy H. B. Lamb.)

CHAPMAN'S BLACKSMITH SHOP, C. 1910. This building still stands at the junction of Ashby and High Streets with Noank Road. Twelve-year-old Helen May Clarke, who lived nearby, wrote in her diary that she did not care for Mr. Chapman or the smell of the shop, "but the forge and sparks are fascinating."

E. C. George Antiques, c. 1925. E. C. George, who lived down the hill on Library Street, ran his antiques business at 2 Elm Street. The building was once the carriage house for the Louisa Gardner residence (1879), at 8 Elm Street. The carriage house was moved to this location after 1900 and is now a private residence.

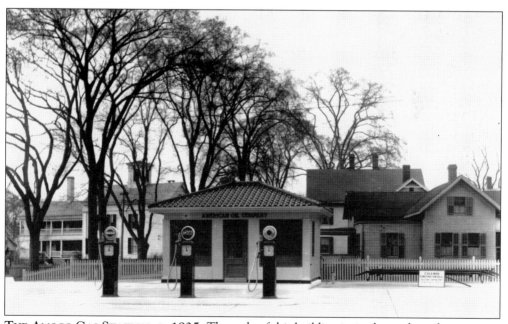

The Amoco Gas Station, c. 1935. The style of this building is similar to that of gas stations on the Merritt Parkway. This was previously the site of the C. H. Mallory house and later the Lamphere Boarding House. In the early 1970s, Bess Eaton Donuts built a shop here. The shop was destroyed by fire in May 2003, but the company planned to rebuild.

THE LAMB FARM, C. 1940. This overview shows Norman Lamb's family farm. In season, he would sell vegetables and fruit at his roadside stand. The farm was between the Mystic River and Route 27, north of the present Route 95 overpass. In the 1970s, the so-called Mystic Triangle began to be developed within this area, which had previously been farmland. The land along Route 27 is now fully developed with motels, restaurants, a shopping center, and on- and off-ramps for the highway. (Courtesy Nancy Strawderman.)

Eight

FLAMES ON MAIN STREET

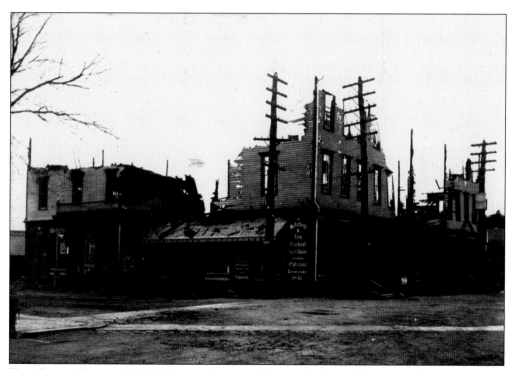

THE OPERA HOUSE, 1900. This was the second fire at the Opera House, on the corner of East Main and Cottrell Streets. In 1885, the building was nearly destroyed. In 1900, an article in the *Mystic Journal* read, "All that remains . . . are the sides up to the second story window including the charred remains of the interior." The article went on to note that 70 Stonington firemen came by special train to give aid.

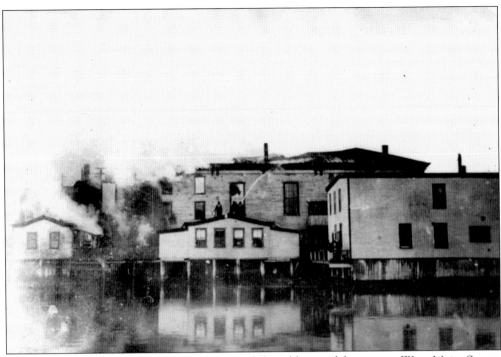

CENTRAL HALL, 1910. This building, one of the oldest and largest on West Main Street, has experienced many fires. The blaze in 1910 was at least the third major conflagration. The *Westerly Sun* reported at the time of this fire that when additional help was needed, the Mystic fire companies sent an automobile down to Noank to tow their engine up to Mystic.

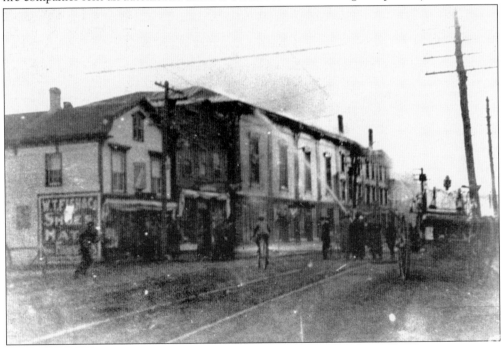

THE HOXIE FIREHOUSE, C. 1925. The B. F. Hoxie Fire Company No. 1 (organized in 1874 as Mazeppa No. 1) was the first permanent Mystic fire organization. Its original fire station, on Holmes Street, burned in 1897. This picture shows the company's next headquarters, on Cottrell Street. That burned in the 1940s, and a new building was built down the street. When the company outgrew that station, a fourth station was built on Broadway in 1992. The last Cottrell Street station is now a private home.

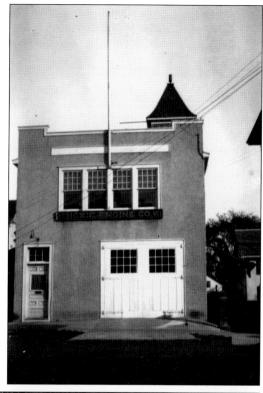

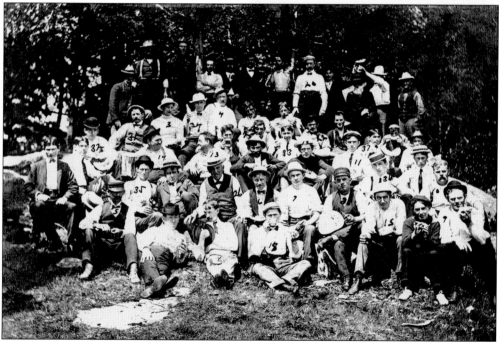

THE HOXIE FIRE COMPANY, C. 1915. Firemen enjoy a picnic and camaraderie on a summer day. Organized in 1875, the company was named the B. F. Hoxie Company No. 1, in honor of Mr. Hoxies $1,000 donation for a new steam engine.

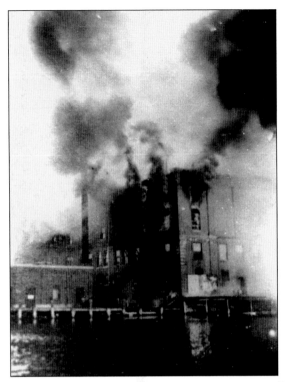

THE GILBERT BLOCK, 1915. The *Mystic Journal* reported on June 25, 1915, "The Gilbert Block, pride of Mystic business center, built six years ago at the cost of $80,000, was partially destroyed by fire at six o'clock this morning." The Hoxie and Mystic hook-and-ladder companies responded and then called New London's Niagara Hose Company and the Noank Hose Company for assistance. The damage was estimated to be between $75,000 and $100,000.

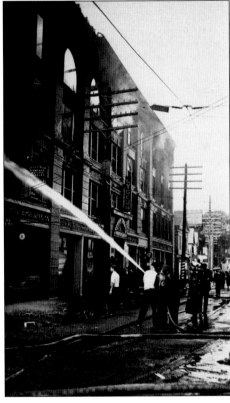

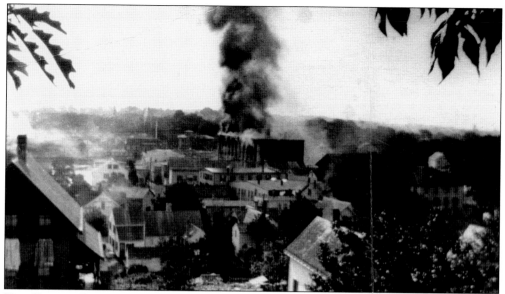

THE GILBERT BLOCK DURING AND AFTER THE BLAZE, 1915. The fire started in the scenery of the theater on the third floor of the building. Because of a lack of water pressure, the fire was soon out of control, and the firemen were driven from the building by the flames. Outside, they were able to contain the fire to this building alone, but the interior was destroyed.

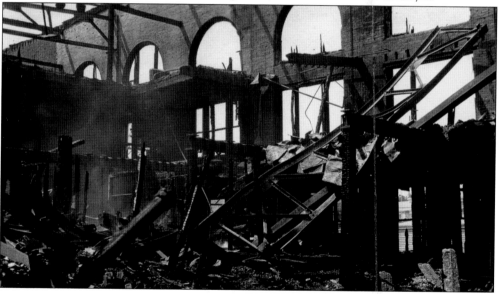

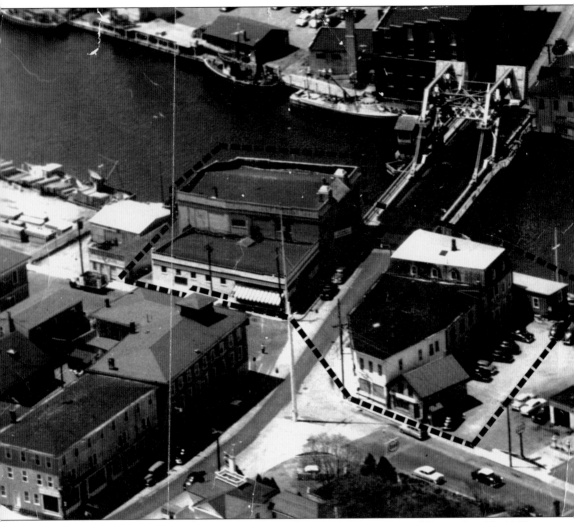

THE MYSTIC FIRE OF 1960. Early on the frigid and windy morning of December 12, 1960, a devastating fire on the east side of downtown Mystic destroyed nine stores, a movie theater, and six offices. This aerial view shows an outline of the area lost. This part of town had not suffered such a fire since 1858, when this same area, including the hotel shown on the left, was ablaze. There was no organized fire company at that time, so the village had to wait until help came from Upper Mystic (Old Mystic). In 1960, Mystic had its own two companies. Ten more companies came in from outlying communities to battle the flames. Through the efforts of these firefighters, the adjacent Cottrell lumberyard and the Hotel Mystic were saved from any major damage, but the rest of the area was destroyed. (Courtesy James McKenna.)

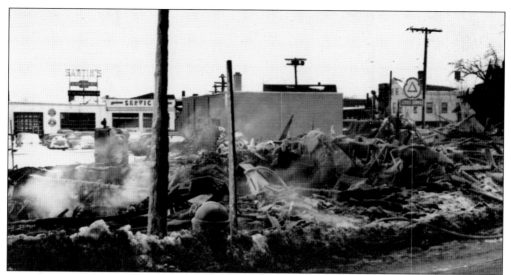

THE NEWBURY BLOCK, DECEMBER 12, 1960. At the corner of Holmes and East Main Streets, this rubble is all that is left of the Newbury Block. On the first floor, Slifkin and Son Hardware, the Mystic Storm Window Company, Mystic Laundrette, Bugbee and Son Plumbers, Mystic Pharmacy, and D'Amico's Barbershop were all lost, as well as the six offices on the second floor. Adjacent to the river, Davy's Newsstand was also destroyed.

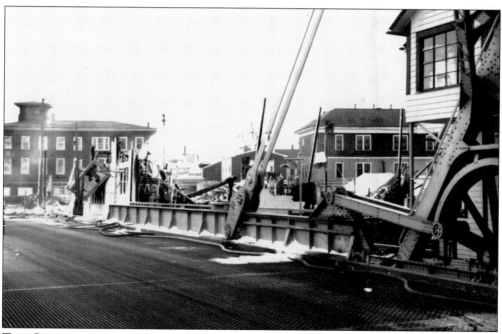

THE CORNER OF EAST MAIN AND COTTRELL, DECEMBER 12, 1960. In this photograph, taken from the bridge southeast of Main Street, there is now a clear view of the former Hoxie House and the Odd Fellows hall. The block—which had housed Kinney Jewelers, Noyes' Dry Goods, and the Strand Theater—is now just charred wood and ashes. Only one business rebuilt on this property.

THE STRAND, 1960. The marquee and three windows are all that is left of the Strand Theater. The theater was built in the 1920s with a section that extended out over the river. Helen May Clarke wrote in her diary about going to the Saturday afternoon matinees, where she fell in love with Rudolph Valentino. Adults enjoyed the theater too, except for the occasional water rat scurrying under their feet. The theater was never rebuilt.

THE AVERY BLOCK, 1975. Allen Avery built this building on West Main Street in the mid-1800s. Avery owned a furniture store and also advertised coffins and mortuary services. The building has always housed two businesses. In 1880, F. B. Smith sold ship plumbing supplies and furnaces next-door to the furniture shop. The building was rebuilt after this fire and again houses two retail businesses.

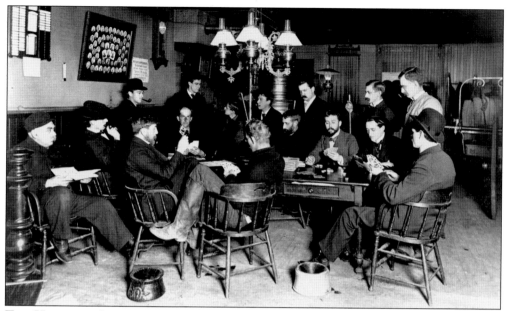

THE HOOK-AND-LADDER COMPANY, C. 1910. Some members play cards in the firehouse while others have a game of pool. Their first pool table was purchased in 1895, and the first pool match was held in 1899, with the Hooks winning over the Westerly Riverside Wheelmen 399-394. A bridge tournament was formed in 1927. The Hooks still have an original pool table and some of their original furniture.

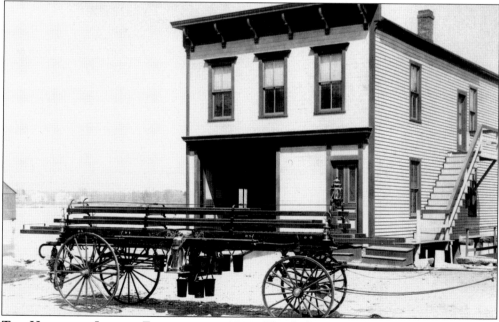

THE HOOK-AND-LADDER FIREHOUSE, C. 1912. The firehouse was built on Gravel Street in 1884 just to house the ladder truck, but by 1912, a second floor and an extension had been added. The ladder truck pictured here was the second, purchased in 1887. In 1918, the Mystic Fire District acquired a new automotive hook-and-ladder vehicle. In the 1960s, the Hooks moved their headquarters up the hill to their present location on Route 1.

THE WHALERS' INN, 1975. Fire struck the hotel corner of East Main and Cottrell Streets in 1975. New owners had taken over the building in 1965 and made major renovations, but after this fire only the aluminum siding remained. Parts of the building were over 100 years old, but nothing could be salvaged and the building was razed. Rebuilt and recently restored to the original design, the hotel stands intact once again.

THE CENTRAL HALL BLOCK, 2000. Mystic lost one of its earliest, largest, and busiest downtown buildings in this fire. The fire spread quickly, and eight businesses were burned out. The building that once hosted roller-skaters on its third floor, as well as speakers such as William Lloyd Garrison and Julia Ward Howe, was completely destroyed. Today, only a wooden safety wall along the sidewalk marks its location.

Nine

OTHER MATTERS
OF INTEREST

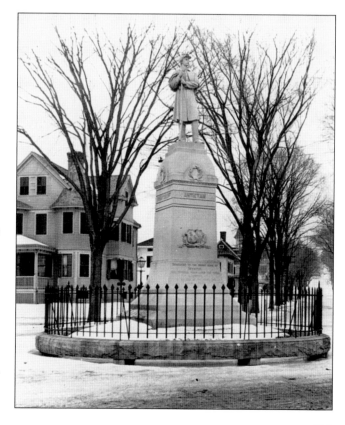

**THE CIVIL WAR MONUMENT,
C. 1883.** This monument was
unveiled and dedicated during
a comedy of errors. First, the
bleachers slowly collapsed,
unsettling the invited guests,
and then the gun salute was
mistakenly aimed directly into
the oncoming parade. Injuries
were light, and the activities
went on as planned. (Courtesy
the Indian and Colonial
Research Center.)

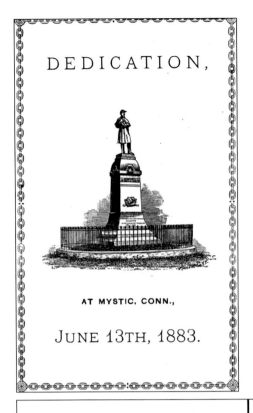

DEDICATION,

AT MYSTIC, CONN.,

JUNE 13TH, 1883.

A DEDICATION INVITATION, 1883. The invitation to the dedication ceremony included the program for the day, as well as the names of the committee and dignitaries attending.

You are hereby cordially invited to be present on June 13th, and participate in the Dedication of a Soldiers' Monument, erected by one of our patriotic citizens and dedicated to the memory of the brave Sons of Mystic who offered their lives for their country in the War of the Rebellion, 1861---1865.

Following is the general Order of Exercises:

Orator, Gen. Joseph R. Hawley.

Poet, Chaplain Fred'k Denison.

A Chorus of 100 Voices
Will be Conducted by Mrs. Dr. F. A. Coates.

A Salute will be fired
By a Section of Artillery from Fort Trumbull.

Exercises at the Monument,
Near the Congregational Church, Mystic Bridge,
will Commence at Eleven o'clock.
Invited Guests will be furnished with Seats.

The Parade will begin at 1 o'clock.

Dinner will be served
On Jackson Avenue, at Two o'clock.

◆◆◆

His Excellency Gov. T. M. Waller and Staff, Commander J. B. Hyatt, Department of Conn. G. A. R. and Staff, Hon. John T. Wait, Gen. A. C. M. Pennington and Officers from Fort Trumbull, and other distinguished gentlemen are expected to be present.

◆◆

JOHN K. BUCKLYN,	
J. ALDEN RATHBUN,	Committee of
C. H. ROWE,	Williams Post,
PARMENAS AVERY,	No. 55, G. A. R.
JOHN G. PACKER,	

CAPT. JAS. H. LATHAM, Marshal.

L. M. Guernsey, Press Print, Mystic River.

THE JOHN MASON MONUMENT, C. 1890. In June 1637, Maj. John Mason led a group of English soldiers, along with some friendly American Indians, on a raid on the Pequot Indian settlement on Pequot Hill in Mystic. The raid turned into a massacre that decimated the tribe. To honor Mason, the state erected a bronze statue of heroic size, with a plaque commemorating the battle. It was dedicated in June 1889. (Courtesy Judy Hicks.)

THE JOHN MASON MONUMENT, 1995. A century after its dedication, the monument became a controversial subject. After many public debates, the state moved it in 1995 to Windsor, a town that John Mason helped settle. In this picture, the statue is being loaded onto a state truck. The boulder and base, which held the plaque, were also removed, and the bronze plaque was given to the Mystic River Historical Society at their request. (Courtesy Judy Hicks.)

113

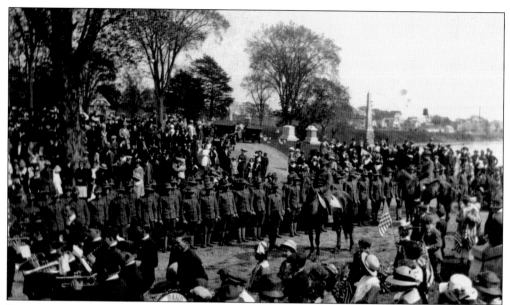

DECORATION DAY AT THE ELM GROVE CEMETERY, 1915. Exercises were held near the Mystic River after a long dusty walk from downtown. Helen May Clarke wrote in her diary that it was "very somber marching through the big Mallory gates under the big flag and the slow, slow steps to the Dead March give me chills." (Courtesy Eleanor Jamieson.)

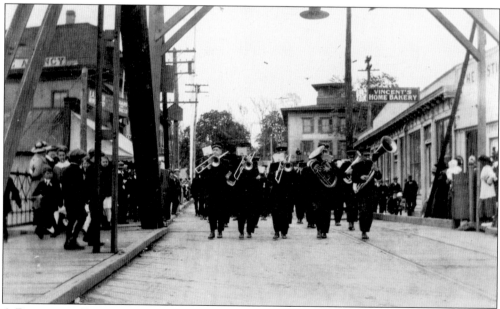

A PARADE ON EAST MAIN STREET, C. 1915. The brass band approaches the bridge as families watch from the sidewalks. The Hotel Mystic is in the rear, and Agnes Park's Mystic Variety Store is across the street along with a bakery and a fish market. (Courtesy Eleanor Jamieson.)

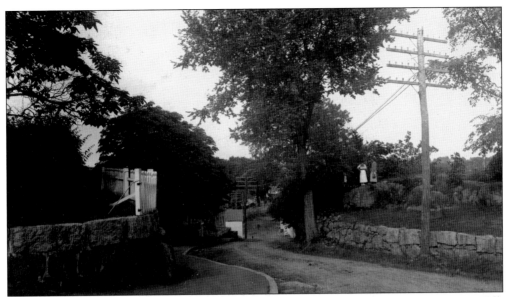

NEW LONDON ROAD, C. 1910. In this view looking toward downtown from atop Baptist Hill, the Tift property is to the left. Farther down the hill stands the building that is now Mystic Pizza. On the right, the stone wall is much lower than the wall is today. At this time, houses lined this side of the street almost to the intersection with Water Street. (Courtesy Dorrie Hanna.)

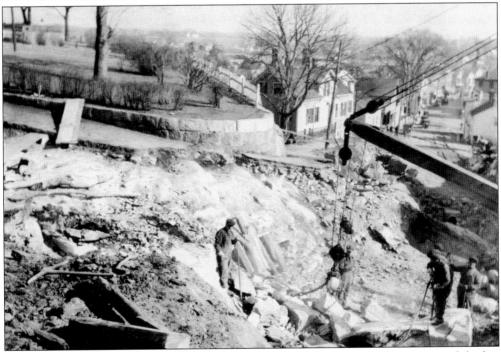

BAPTIST HILL, 1924. The wall along New London Road here on the hill became much higher after the construction work in 1924. The configuration of the New London Road (Route 1) was changed to facilitate increased automobile traffic. A house near the Baptist church was razed, and the level of the road was lowered at the top of the hill. New London Road now ran straight up the hill and connected with the old New London Road to the southwest.

NEW LONDON ROAD, 1924. Here at the top of the hill, where Allyn Street and West Mystic Avenue intersect with the New London Road, the road lowering continues. The Allyn house is to the right. The elm trees were lost in the 1938 hurricane, but new young trees have been planted in their place.

BAPTIST HILL, 1924. The extent of the work on New London Road is illustrated here. Ledge has been cut through on the left. The same will be done on the right. The Union Baptist Church, whose front steps were originally at street level, will now require many steps to the main entrance high above the road. The house that was razed stood where the equipment is grouped in the center of the picture.

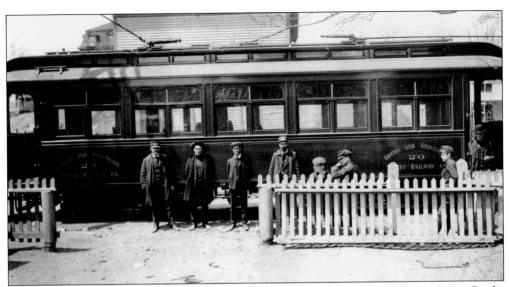

A GROTON AND STONINGTON TROLLEY CAR, C. 1904. Trolleys had come to Mystic. Bright new cars crossed Groton and Stonington on shiny new rails, providing transportation for schoolchildren, businessmen, and even dancers going to the Mystic Casino. The service continued until 1928, when buses replaced trolleys as public transportation. (Courtesy Bernard L. Gordon.)

A GROTON AND STONINGTON SNOWPLOW TROLLEY, 1989. This Taunton snowplow trolley car was retired in 1928 and bought by a Mystic resident. He used it for his ham radio equipment during the next two decades, but it was then abandoned. The Mystic River Historical Society found a home for it, and on this day, with local help, the car was lifted onto a flatbed truck and carried away to the Seaside Trolley Museum in Kennebunkport, Maine, for restoration.

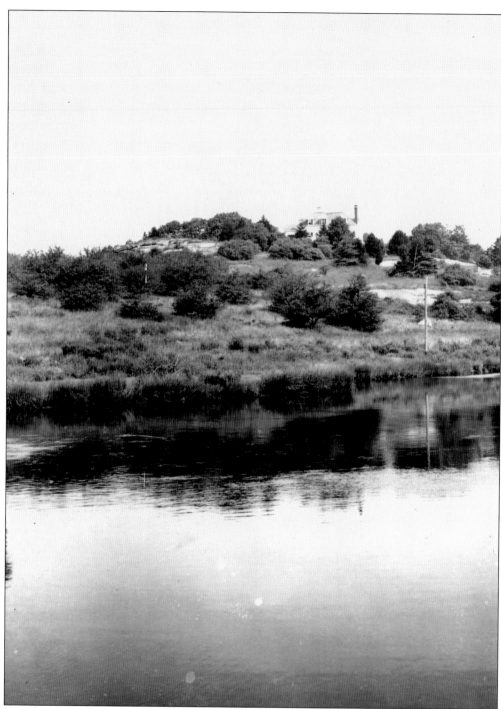

THE HALEY MANSION, C. 1930. In this view looking up from the waters of Williams Cove on the east side of the Mystic River, the mansion is seen at the top of Reynolds Hill. The mansion is now the Inn at Mystic, with its gardens and terraces all restored. To the left, the inn proprietors have built a large motel and restaurant that spills down the hill. Route 1 crosses this cove now, and the area is built up with homes and businesses.

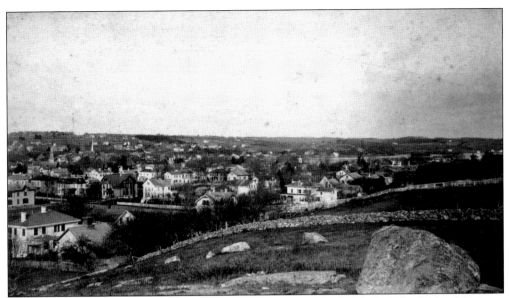

MYSTIC, C. 1910. The east side of Mystic, as seen from the hill below the Haley Mansion, is a small and compact grouping of homes. To the upper right of this view looking upriver, the Greenmanville Chapel cupola can be seen. To the left are the spires of the Mystic Congregational and Methodist churches. The boulders and stone walls are indicative of this side of Mystic's town affiliation—Stonington. (Courtesy H. B. Lamb.)

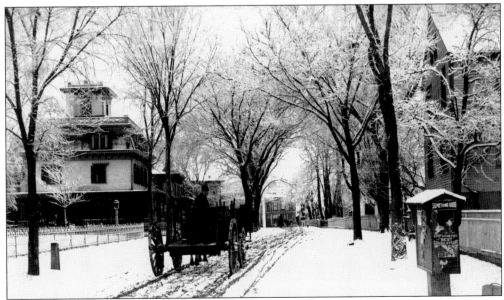

EAST MAIN STREET, C. 1900. A horse-drawn wagon on East Main Street heads toward the bridge. The house on the left was the home of Charles Henry Mallory. The Bess Eaton doughnut shop is there now. The elm trees were all lost in the 1938 hurricane. The notice board in the right foreground advertises "the Best Cough Syrup." (Courtesy H. B. Lamb.)

WATER STREET, C. 1906. On the right are the Groton and Stonington Railway Company's buildings. The larger buildings have been converted into condominiums. A horse-drawn buggy drives to one side of the trolley tracks through light snow. On the left is a two-family home built in the 19th century. It still looks much the same today. (Courtesy H. B. Lamb.)

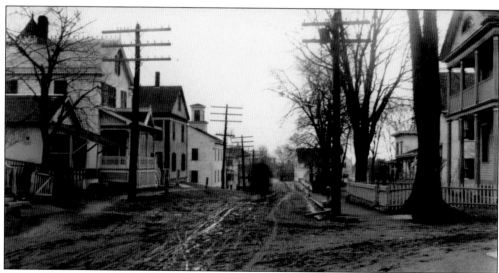

LOWER HIGH STREET, C. 1906. This is the corner where one would turn left when coming up Baptist Hill in order to reach the former lower end of the New London Road. The house on the right, a mirror image of the one opposite it, was razed for the construction of the new New London Road. Portersville Academy is down on the left. The two houses up the street from it are still standing. (Courtesy H. B. Lamb.)

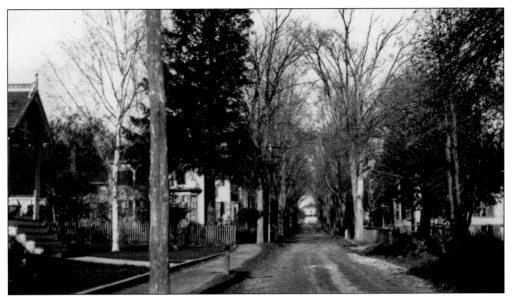

ELM STREET, C. 1906. This view, looking north from New London Road, shows why the street was named Elm Street. The Mystic and Noank Library is on the right in the next block, and across from it is the large home of Capt. Elihu Spicer. The street ends at Burrows Street, which can be seen in the background. The trees are mostly gone, but the houses are all still there. (Courtesy H. B. Lamb.)

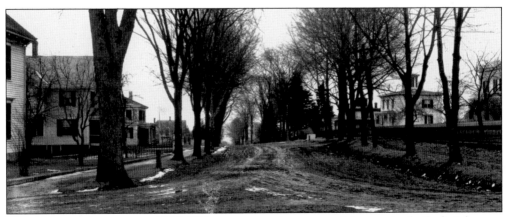

WEST MYSTIC AVENUE, C. 1906. This street was where many ship captains built their homes. The road was dirt then and the trees much more plentiful, but most of these large homes appear today much as they did when they were built in the 19th century. The picture was taken from the intersection with New London Road, looking south. (Courtesy H. B. Lamb.)

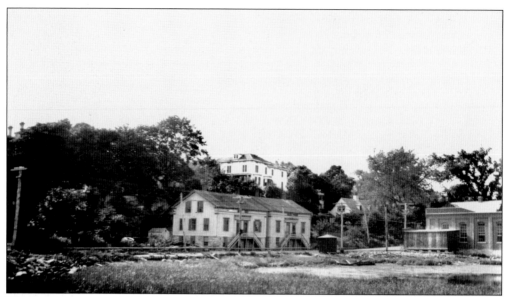

WATER STREET, C. 1905. Up on the top of the hill, in the center of the picture, stands a large house on High Street that was known as the Buckley house. Helen May Clarke wrote in her diary that one of her ancestors, a Packer, had built this "mansion." In 1919, it was converted into apartments. In 1987, it was torn down and replaced with a new home. (Courtesy H. B. Lamb.)

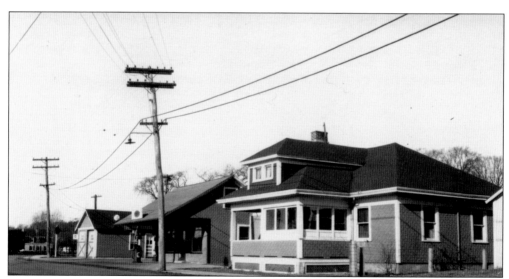

ROOSEVELT AVENUE, C. 1925. This view shows the north side of Roosevelt Avenue right across from the railroad station. At the corner of Broadway, the street has been completely changed. The Hagman Brown gas station and the Prunier house have been razed and replaced by a convenience store, which also sells gas, and commercial buildings fill the rest of the block.

THE CHARLES W. MORGAN BEING TOWED TO MYSTIC SEAPORT, NOVEMBER 1941. The *Morgan* was launched in 1841 at the shipyard of Jethro and Zachariah Hillman in Fairhaven, Massachusetts. After the *Morgan's* whaling days ended, the vessel was preserved by Whaling Enshrined Inc. under the leadership of Harry Neyland and Col. E. H. R. Green, son of multimillionaire Hetty Green. Relying largely on photographic evidence, Mystic Seaport's restoration shipyard has restored the *Charles W. Morgan* to the way it appeared *c.* 1905.

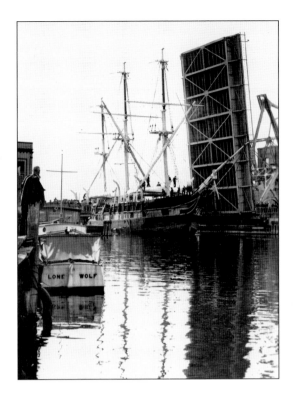

THE WORLD WAR I MEMORIAL, c. 1935. After the road was rerouted on Baptist Hill, there remained a little triangle of land between New London Road and Library Street. This land was appropriated for a monument honoring Mystic men and women who served their country during World War I. A little bit of the road can be seen to the left, and the first house on Library Street is to the right.

THE MASON HOMESTEAD, C. 1925. This house sits on part of the land originally given to Maj. John Mason by the colony of Connecticut. He later bequeathed this piece to his younger son, Daniel Mason. First known as Chippechaug Island in Mystic Bay, it later came to be called Masons Island. At the time of this photograph, descendants of Daniel still occupied the house. In the 1950s, the house burned down during a trash fire that got out of control.

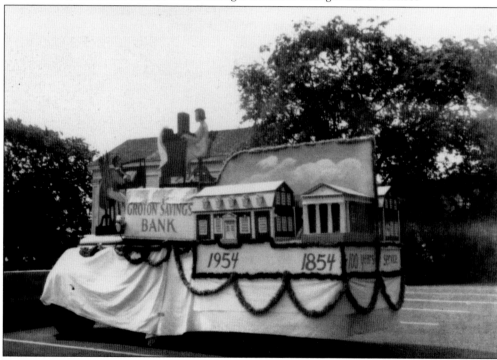

THE MYSTIC TERCENTENARY PARADE, 1954. The float for the Groton Savings Bank commemorates Mystic's 300th anniversary as well as the bank's 100th birthday. This parade was long, and all the decades past were well represented. The book you are reading is in celebration of another 50 years for Mystic.

Skeleton of a Whale, Captured in Hudson Bay in 1879
from Schooner "Era,"
John O. Spicer, Master.
Jaw bones 18 feet long.
Full length estimated 90 feet.
Mounted by Chas. Q. Eldredge,
Old Mystic, Conn., 1919.

Tons of Whalebone, Secured by
a New London Captain
in the good old days—
Presented by The Mariners
Savings Bank, 1924.

THE CHARLES Q. ELDREDGE MUSEUM. Charles Q. Eldredge, at the age of 72, opened his private museum in 1917. The free admission museum had a diverse collection, some items far more credible than others, and it attracted many visitors. Eldredge, by himself, built the museum building, and mounted and displayed all of his exhibits. The museum and his individual curios were sold at auction in 1937, a year after his death.

GRAVEL STREET, C. 1970. The Mystic Art Festival, begun in 1957, attracts over 100 artists and thousands of visitors every August. In the early days, the exhibits ran down the side streets off West and East Main Streets. Today, West and East Main Streets, plus Cottrell and Water Streets, hold the majority of exhibits. This picture shows that Gravel Street residents once had works of art on their lawns and hundreds of people wandering down their street.

BANK SQUARE, C. 1959. Workers are cutting down the old elm tree in front of the bank building. The gas station property at the right is now the site of Bank Square Books. The trolley tracks have been either taken up or paved over. When roadwork was being done near this corner recently, the Mystic River Historical Society acquired a piece of the trolley rail. It is now resting alongside Portersville Academy.

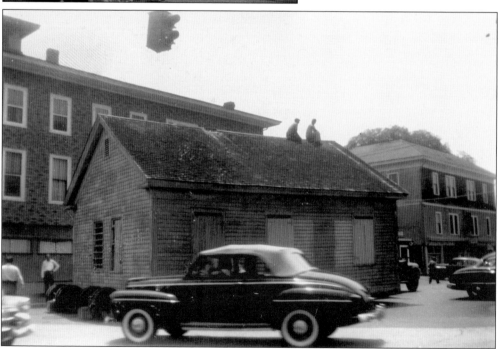

THE LOCKUP HOUSE, C. 1953. Mystic Bridge's 1885 one-cell lockup was swept upriver from its site near Forsyth Street during the 1938 hurricane. In 1953, the Cottrell Lumber Company purchased the building and moved it to its present location on the corner of Washington and Cottrell Streets. It is used for retail business today.

MARY L. JOBE (1886–1966), C. 1920. Jobe designed this uniform for her summer campers at Camp Mystic. She was very strict about having it worn just this way. Although her white middy, scarlet tie, blue knickers, black stockings, and white tennis shoes were a little warm for the season, she felt that uniformity was necessary in camp life. She was a tall, attractive woman, and the uniform looked handsome on her, but some of the girls might have found it heavy and hot. (Courtesy the Akeley Trust)

BIBLIOGRAPHY

Clarke, Helen May. *An Account of My Life.* Mystic, Connecticut: Mystic River Historical Society Inc., 1997.

Comrie, Marilyn, and Carol W. Kimball. *The Union Baptist Church of Mystic, Connecticut: Its Story.* Mystic, Connecticut: Union Baptist Church, 1987.

Cutler, Carl C. *Mystic: The Story of a Small New England Seaport.* Mystic, Connecticut: Marine Historical Association Inc., 1945.

Haynes, William. *1649–1976 Stonington Chronology.* Chester, Connecticut: Pequot Press, 1976.

Hicks, J. A., ed. *Mystic River Anthology.* Wickford, Rhode Island: Dutch Island Press, 1988.

Kimball, Carol W. *The Groton Story.* Groton, Connecticut: the Groton Public Library and Information Center, 1991.

Mystic Bridge Historic District Study Committee Report. Stonington, Connecticut: Town of Stonington, 1975.

Peterson, W. N. *"Mystic Built": Ships and Shipyards of the Mystic River, Connecticut, 1784–1919.* Mystic Connecticut: Mystic Seaport Museum Inc., 1989.

Peterson, W. N., and P. M. Coope. *Mystic Buildings at the Mystic Seaport Museum.* Mystic, Connecticut: Mystic Seaport Museum Inc., 1985.

Stark, Charles R. *Groton, Conn. 1705–1905.* Stonington, Connecticut: Palmer Press, 1922.

Stonington Industries. Stonington, Connecticut: Tercentennial Committee, 1949.

SAILBOATS AT THE MOUTH OF THE MYSTIC RIVER, C. 1925. This peaceful picture shows the river on a calm summer day. The village of Noank is to the right. Today, this view would be filled with many more pleasure craft of all descriptions.